E.B.COX

A LIFE IN SCULPTURE

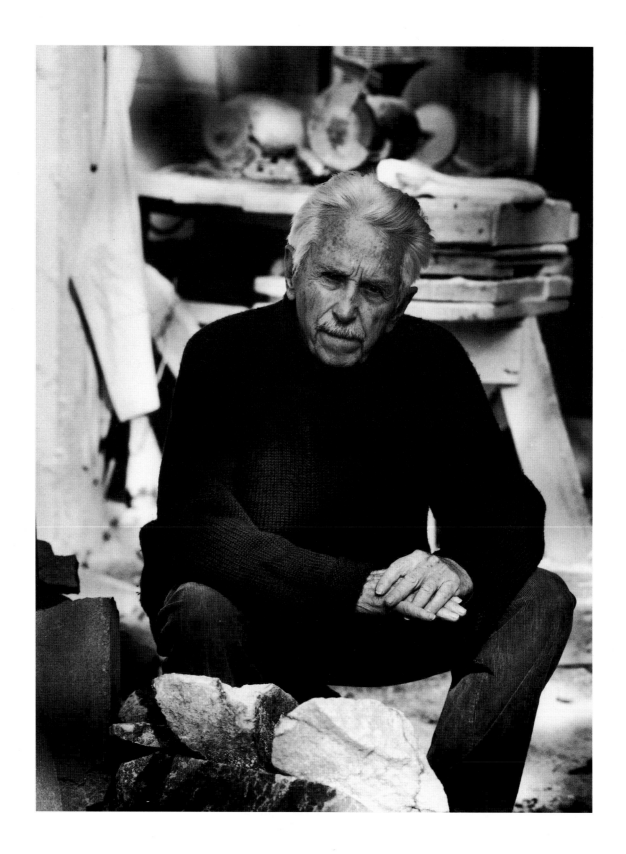

E.B. COX

A LIFE IN SCULPTURE

TEXT BY

Gary Michael Dault

NEW PHOTOGRAPHS BY

Rob Davidson
Steven Evans
Deborah MacNeill

The BOSTON
MILLS PRESS

Canadian Cataloguing in Publication Data

Cox, E. B. : a life in sculpture
ISBN 1-55046-304-7

1. Cox, E. B. I. Title

NB249.C69A4 1999 730'92 C99-931858-6

Published in 1999 by
BOSTON MILLS PRESS
132 Main Street
Erin, Ontario N0B 1T0
Tel 519-833-2407
Fax 519-833-2195
e-mail books@boston-mills.on.ca
www.boston-mills.on.ca

Distributed in Canada by
General Distribution Services Limited
325 Humber College Boulevard
Toronto, Canada M9W 7C3
Orders 1-800-387-0141 Ontario & Quebec
Orders 1-800-387-0172 NW Ontario & Other Provinces
e-mail customer.service@ccmailgw.genpub.com
EDI Canadian Telebook S1150391

Distributed in the United States by
General Distribution Services Inc.
85 River Rock Drive, Suite 202
Buffalo, New York 14207-2170
Toll-free 1-800-805-1083
Toll-free fax 1-800-481-6207
e-mail gdsinc@genpub.com
www.genpub.com
PUBNET 6307949

Design: Arnold Wicht
Assistant Designer: Angie Cameron

Project Management: Kenneth D. Smith and Elspeth Black

Front Cover: E.B. Cox, *The Three Graces , The Garden of the Greek Gods,*
Canadian National Exhibition, Toronto, 1963, limestone

Back Cover: E.B. Cox quartette from colour plates

THE CANADA COUNCIL | LE CONSEIL DES ARTS
FOR THE ARTS | DU CANADA
SINCE 1957 | DEPUIS 1957

We acknowledge for their financial support of our publishing
program the Canada Council, the Ontario Arts Council, and
the Government of Canada through the Book Publishing
Industry Development Program (BPIDP).

Printed and bound in Hong Kong, China
By Book Art Inc., Toronto

CONTENTS

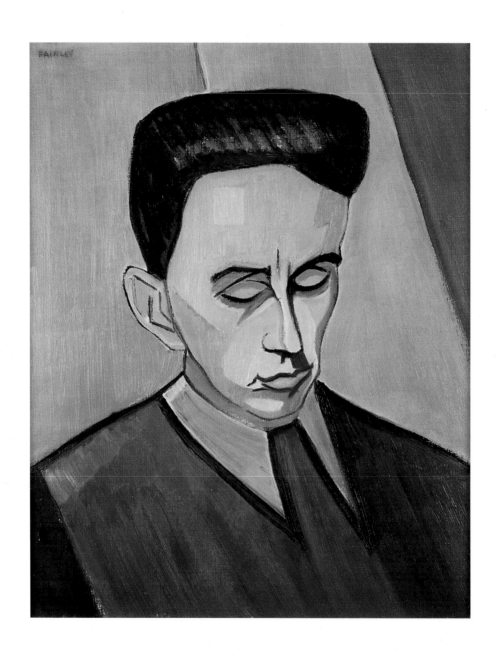

Foreword

E. B. Cox has been quietly creating works in his own style for over five decades, all the while carefully avoiding the glare of the media and the promotional support of an art dealer. Now in his eighties, he still rises early each day to begin sculpting in his studio behind his Toronto home. Years ago, as a teenager, he whittled tiny treasures. As he matured, his passion for sculpting grew steadily and a teaching career at Upper Canada College was soon abandoned. Sculpting was to be his full-time profession.

Isolated portions of E. B.'s work have been exhibited over the years as clients commissioned pieces for specific sites. *The Garden of the Greek Gods*, featuring huge limestone sculptures of these mythical figures, once adorned the Georgian Peaks Ski Resort and are now displayed permanently at the Canadian National Exhibition (CNE). In Milton, the grounds of a school are filled with whimsical creatures such as swans and turtles, crafted for the pleasure of the young students.

A *Great White Lady* sits serenely among the foliage at McMaster University in Hamilton. E. B.'s distinctive bears may be sighted at the CNE and the Guild Inn. At Toronto's landmark Park Plaza Hotel, thousands have delighted at Cox's fish fountain. It is safe to say that virtually anyone who has lived in or visited the Toronto area has experienced the pleasure of viewing E. B. Cox's sculpture. The pieces are everywhere, and many people have enjoyed them for a lifetime without realizing who created these wonderful works.

The Toronto area has been enriched by countless Cox installations in locations both prominent and modest.

The mediums vary — materials include marble imported from Italy, alabaster, sodalite, wood, precious and semi-precious stones, and stones unique to Canada. The tools can range from power tools to fine precision instruments. Location also fluctuates — when the bitter days of winter preclude outside work, E. B. focuses on faceting precious stones.

Through the years, E. B.'s powers of perception have not failed him — he is indeed a first-hand observer. The sculptures clearly and confidently demonstrate that art can enhance our vision of the world. At the same time, these sculptures are subtle statements that capture the intrinsic nature of his subjects. We catch a glimpse of a bird's wing, its tail or its beak. We get an impression of the weight, the mass, the lumbering motion of a massive bear. We stare at an inscrutable, implacable face or gaze appreciatively at the simple grace and dignity of the human form.

E. B. seems perfectly aware that the medium, be it wood or stone, must be pushed and prodded, coaxed and cajoled. Often it pushes back, demanding its own form. But art is, by nature, exploratory. Sometimes what the mind's eye perceives changes as the piece progresses — sometimes the finished work is vastly different, sometimes it's better, sometimes it's magic!

Wendy Ingram, Publisher

Preface

THIS BOOK, conceived in the last year of this millennium, depicts a half century of outstanding sculpture by Canada's foremost sculptor in stone, Elford Bradley Cox.

The sculpture of E. B. Cox has been described as the great bridge between the native art of Canada and the modern art of the twentieth century.

Cox's work seamlessly explores a broad range of modern sculptural styles and fuses these with the West Coast themes that have gripped him throughout his life. This book combines a wonderful collection of photographs of his works taken over the past half-century with stunning new photography by award-winning photographers.

It contains a superb sequence of photos by Ray Webber, taken in 1960, chronicling the creation of a seated figure from seven tons of rough stone to the finished masterpiece now known as the *Great White Lady,* at McMaster University, Hamilton, Ontario.

These amazing photos show how E. B. Cox, who really pioneered the use of power tools in stone sculpture, was able to create dozens of massive works of art single-handedly. Another remarkable series of photographs illustrates the colossal tour de force known as *The Garden of the Greek Gods*, in their original setting on the slopes of Georgian Peaks, near Collingwood, Ontario.

The group of stone animal sculptures installed at the School for the Deaf in Milton was photographed for this book by well-known photographer Steven Evans. Steven Evans also sensitively captured several other major outdoor pieces in exquisite long-exposure black and white.

In early 1999, scores of E. B. Cox works were assembled for the first time from various private collections and were photographed in dramatic colour by award-winning studio photographer Rob Davidson.

In addition, Deborah MacNeill, a leading Toronto photographer, was commissioned to take new photographs of E. B. Cox and to record a major exhibition held in November of 1998 at the Gallery of the Sculptors' Society of Canada. Her portraits of the artist taken in the fall of 1998 reflect the enduring dynamism and power of the sculptor in his ninth decade.

The text by Gary Michael Dault provides a fascinating insight into E. B. Cox's inspiration and dedication to his art.

Acknowledgments

SPONSOR

This book was made possible by the generous support of Lombard Insurance,
a leading Canadian-owned property and casualty insurance company.

CONTRIBUTORS

From its inception, the production of this book was aided by the efforts of various skilled and dedicated individuals.

The generous contribution of the following professionals and collectors is gratefully acknowledged:

Arnold Wicht, for conceiving and creating the design for this book.

Angie Cameron, graphic designer, for providing production and technical assistance with the layout.

Deborah MacNeill, Toronto-based commercial photographer, for taking the recent portraits of E. B. Cox and the photograph of his 1998 exhibition.

Agi Lovasz, Jim Higginson and Alison Black, for taking preliminary photographs of the sculptures and installations.

Eric and Fiona Conroy, Elford Bradley Cox, John and Wendy Ingram, Hy Rosenberg, Kenneth Smith and Elspeth Black, Stanley Stadnyk, Steven and Kathy Sutton, Kenneth and Gloria Torrance, Harvey Wolfe, Terence and Patricia Wardrop, and Arnold Wicht, for loaning sculpture from their private collections for studio photography.

Gordon and Wendy Weiss for permitting photography at Deerwood.

"In 1938 I met members of
The Group of Seven and I was thrilled
to meet real artists for the first time.
Little did I know that I would end
up doing their gravestones."

E. B. Cox

E.B. COX: A LIFE IN SCULPTURE

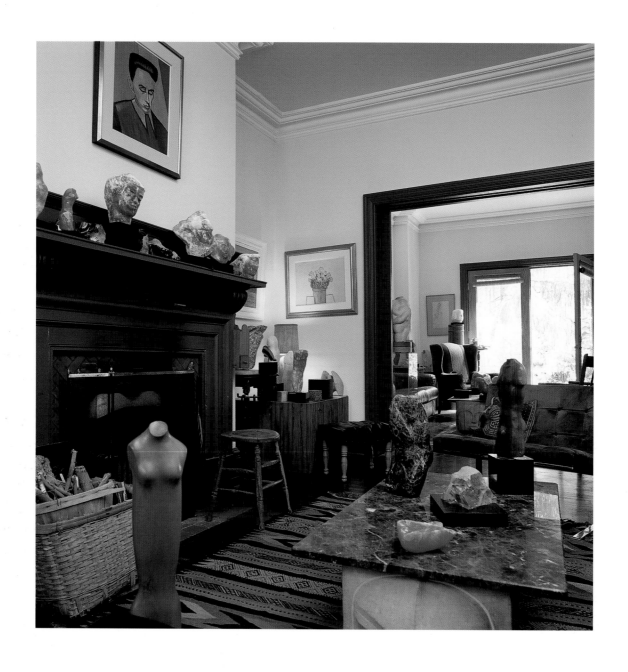

E. B. Cox: A Life in Sculpture

t's always morning when I visit E. B. Cox. I knock at the front door of his exquisite Victorian heritage house in Toronto's Riverdale district — a gingerbread house that seems like an enterable vision of a more gracious past, momentarily set down among its unsuspecting neighbours — and I wait there, knowing all the while that he's not inside anyhow, knowing that he's sure to be out back, down at the end of the driveway, beyond the garden, past his beloved tamarack tree, already working in his studio.

Now eighty-five years old, Cox is a sprightly, elfin sort of man, with a perpetual twinkle in his eyes, and it's always amusing — and touching — to see him having his way with a massive block of wood, wielding his air-hammer with the easy authority of a man carving a turkey, the wood chips falling where they may. On this particular sunny April morning, Cox is transforming a titanic slice of tree-trunk, a pine, into one of the massive, hemispheric presences he is currently working on — great planetary faces that hover somewhere between two other bodies of work, his sculpted busts and his loving recreations of Northwest coast native masks.

I fear I'm too early, but you can't be too early for Cox. No matter what time you make your visit, he's already been working a couple of hours, and right now he seems happy enough to stop for a cup of tea and a croissant. A few minutes later, we're sitting in his light-filled living room, surrounded by his sculptures — a buttery female torso in wood, a noble head in serpentine, a meandering vein of asbestos dividing its dignified, deep-green visage into upper and lower levels like Freud's superego and id, a graceful little nereid in deep-blue lapis (like one of a pair of parentheses), and a couple embracing so fervently they appear to be shaping from within the stone that encloses them. Outside, on the deck, a gigantic wooden frog a couple of feet long rests in a rough, primordial state, as if evolution had given up on it ("There's more toad in him than frog," Cox notes genially). Nearby, over the fireplace, hangs a portrait of Cox by the sculptor's dear friend and mentor, the late Barker Fairley. Cox studied German literature with Fairley at the University of Toronto and, at Fairley's invitation, had been welcomed into the genial and bohemian world of art and literature that made up the other half of the great scholar's life, a world that included as his intimate friends the painters of the Group of Seven.

"My grandfather could carve," Cox tells me. "He was my mother's father, and he lived with us when he was an old man. There was always cedar-wood around, and a sharp knife, and I was, in fact, never told to stop whittling. It was considered a pleasant pastime for a boy." Wasn't it dangerous, I ask him? "I cut myself *repeatedly*," says Cox, grinning, looking for a moment just as he must have looked when he was eight.

"But so what? Little boys cut themselves and have accidents and fall and break their arms. That's part of being a little boy. But I came to know that you could carve, and that you could make things out of wood. That's the first thing about becoming a sculptor. It's like going to university. The first thing to know about wanting to come, for example, to the University of Toronto," says Cox, "is to know there is one!"

"I could carve," says Cox – who has a nice feel for understatement. "I saw a carving being done [by his grandfather] and I thought, 'Oh, I can do that,' and proceeded to do it. Of course, that was years and years before I realized there was a *career* in it!"

When he went to university, Cox didn't go there to study fine art. "I studied French and German at Victoria College from 1934 to 1938," says Cox. "And while I was there, I joined

a sort of art club with Carl Schaefer. He was very good at influencing and encouraging people. I showed him some trivial little things I'd done and he immediately exhorted me to do some more. 'Carry on!' he used to tell me. Also, I had a friend at University College (I was at Vic, remember) who suggested I go and hear the lectures of Barker Fairley. I sat in on them – and he was certainly a superior lecturer. He took me aside one day.

"'Who are you?' he asked me.

"'I'm Elford Cox,' I told him.

"'Oh, yes, I've heard about you. You're the carver. Well,' said the august Fairley, 'come to my house.' He lived up on Dawlish Avenue near Lawrence Park at that time, and streetcar tickets were four for a quarter then – a bit *too much*! But I dutifully walked there that evening and I sort of fell in with...well, I felt I was being *accepted*! Fairley had a salon, and it was there I met A.Y. [Jackson], Fred [Varley], and Lismer. It was so nice.

I found, at last – after the barren fields of Bowmanville, where I had grown up – I found intelligent people talking about things, and [he grins like a little kid] I was under the impression I *understood* them! I felt at home. I became especially good pals with Barker's son-in-law, John Hall, who was a painter, and still is. And John and I used to go walking on Sunday afternoons and discuss nature and such matters. It was," he chuckles, "quite civilized. I was very fortunate."

"You couldn't go painting together," I point out, with my flair for the obvious, "because you were a sculptor."

"Actually," says E. B. (I cannot go on calling him Cox; our subject here is universally and warmly known as E. B. and so it shall be here). "I used to take a portable wind-up phonograph, and I would play Beethoven records while John painted. Beethoven *en plein air*!" I ask E. B. if he'd ever tried painting, either on these rambles or otherwise. "Nope," comes E. B.'s laconic reply. "I don't like flat stuff!"

This seems strange. Most sculptors, even if they don't spend much time actually painting, do make drawings, and often, by extension, etchings and lithographs. E. B. doesn't make drawings. "As soon as I've done a drawing, the thing's over with," says E. B. "I have sometimes decided to make a drawing of a sculpture, but felt, finally, that I didn't have to do that if I could keep the idea of the sculpture, full and rounded — untouched — in my head. If I can do that, I can remember the idea for several days, until I come to make the work itself." Henry Moore once told E. B. he ought to make drawings. "You should draw, draw, *draw*," admonished Moore. "No, no, *no*!" replied the resolute E. B.

All of which brings up an absorbing aspect of E. B. Cox's method of production. The thing to understand is that E. B. makes sculpture constantly and forever, and he makes it as easily as breathing, and he makes it, moreover, almost as if it were a bodily necessity — which, I suppose you could argue, it is. For E. B., sculpture is a sort of tic, a pauseless response to some inner prompting that keeps him making things. He is massively uninterested in art theory, in art criticism, and in many of the conditions and preoccupations of art as a profession. Well-travelled and well-read, E. B. is, nonetheless, crushingly impatient with the intellectual or even the clerical side of art, always having taken what might be charitably thought of as a cavalier attitude towards, for example, the documentation of his work, having slides and photographs made, assigning stock numbers to his pieces, keeping track of who owns them and where they are, and so on. He lives, in fact, in a sort of perpetual present, unconcerned for the sculptures he made yesterday, willing to be surprised by the sculptures he will come to make tomorrow, but utterly immersed in the work he is doing just at the moment. He is also pretty casual — to the point of eccentricity — about his prices.

"An art consultant came to see me a while back," says

E. B., his eyes alight with high mischievousness, "and she seemed to grow increasingly, even *dangerously* excited when I came to tell her the prices of my work. She found that one piece she liked was only a hundred dollars, one two hundred dollars, that sort of thing.

"'I'll take them all!' she told me.

"'Those are the prices,' I said. 'I didn't say they were for sale.'

"'Well, are they?' she asked me.

"'No,' I said."

What it comes to is this: "I sort of know about art," says E. B., "and I have a vague idea of what I really like. But art is a puzzle. Why do you like it? Well, it either looks right or it doesn't. But *why*? What *makes* it look right? With my own sculpture, I haven't even decided whether I really like it or not!"

With three years out for soldiering during World War II, E. B. began an eleven-year teaching career at Toronto's Upper Canada College (from 1939 until 1950). He taught French and German, not art. And his own art? "I made things in the summers," says E. B. He realized, after a few years, that he wasn't a very good teacher. "I wasn't dedicated to it," he recalls. But he was, increasingly, dedicated to making art. "I was associating more with artists, not with teachers," he remembers. "So I quit. I quit, I think, just before I was fired." This with a wife and two small children.

Cox moved his family to Palgrave, Ontario, to a small farm he had bought earlier — almost as if he had known he would come to leave the College and the city and, in a sense, flee to the destabilizing embrace of art-making. "I liked the country. I'm a country boy," he tells me.

How about making a living? John Hall, who was a painter, was at the same time teaching at the University of Toronto's School of Architecture. "He knew architects," says E. B., "and he would introduce me to people. And I stayed in touch with Barker. I made it my business to know other artists – and architects." The theory was that architects would commission the young artist to adorn their buildings. And that would, in fact, come to happen. But not yet, and not easily. Life in Palgrave was difficult. "It was a very *lean* time," says E. B. After almost five years in the country, the Coxes moved "downtown" to a one-acre plot in the Finch–Bayview area, in the north of Toronto (which, in the early 1950s, was still a sort of countryside) — and stayed there for thirty years.

It was after this last move that E. B. got interested in stone-carving, on a very small scale at first. "'Well,' I thought to myself, 'I guess I'll have to buy myself a hammer and chisel.'" I ask him if carving stone isn't vastly more difficult than carving anything else. "Wood is much more difficult," he tells me. "You have to take your knife and *push* the wood away. You simply chip the stone away. You can't chip wood, though you can split it — and it always splits in the wrong place."

E. B. says he remembers going one day to a stone company to see if he could pick up some scraps of stone, and noticed an air-hammer being used "for architectural purposes" (for the clean shaping of the stones so they would fit properly together). "I remember thinking to myself, 'Oh, that looks easy, I think that I can do that!'. The air-hammer was really not being used, not by other sculptors. Nobody had air-compressors in those days. I remember demonstrating the air-hammer method to some of the sculptors in the Sculptors' Society of Canada and being amused at how repelled they were by it. It was considered, for example, *too fast*! What it really came down to was the fact that using the air-hammer was thought to be tantamount to 'cheating'!" E. B. took no notice. "I had to get the tools I needed made by a blacksmith: I told him I wanted chisels *with teeth on them*, to help me chip away at the stone. He said he'd try."

What did he first make in stone? "I was satisfying an inner urge — which was there all the time — to *shape things*.

It didn't matter whether it was in wood or stone or clay or wax or even plasticine. To shape things, that's what I did." Was he drawn, early on, to certain subjects? "Yes, animals," E. B. replies. "And, of course, heads and faces." What about abstraction? "As a matter of fact," E. B. recalls, "one of my things that first made an impression was a thing called *The Smoky Flame*, which was a wooden piece, a sort of twist and turn carved in wood — very slender because it was carved from a piece of cedar rail. Jackson [A.Y. Jackson] saw *The Smoky Flame* at Barker Fairley's house. He picked it up and held it this way and that and finally said to me, 'Oh, yes, young man, you have nice sense of *form*.' And I didn't know what *that* was, but it was a *good* thing, I guess, and I had it! Basically, you just do what you feel like."

E. B. finally began to get a few commissions — a work for a high school in Leamington, for example. These early commissions came about, says E. B., because of his friendship with John Hall and Hall's architect acquaintances, and also because the young sculptor tirelessly "peddled his wares on Yonge Street, too" (Toronto's main drag, especially in the 1950s), calling at all of the architects' offices in the city. "I didn't wait for the plums to fall into my lap," says E. B. "I went out and shook the tree." (He sometimes sounds the way I imagine Mark Twain used to sound — or maybe Will Rogers.) He also did a lot of lettering, too — incised lettering in wood and in stone. And he carved a great many gravestones. "And I survived," says E. B. "I survived as a sculptor. I've survived for fifty years."

There was, in fact, a pivotal day. "One day," says E. B., "I made a little bear. I called it *Looking Southward*, because it was a seated bear; seated, in my imagination, on the North Pole. One of my architect acquaintances was visiting the studio, saw the little bear, and [E. B.'s voice suddenly attains a childlike hush of wonderment] *he gave me eighty-five dollars* for it!" The scales fell from his eyes. "At that time, I was working a very large garden we had — we needed to grow our own vegetables — and the moment I sold this little bear, I took the hoe and threw it so high and so far that *it hasn't landed yet*! I said to myself, 'I...will... never...ever...hoe...the...garden...again!' I've made about five hundred little bears since then. Every one different," he hastens to add, "because of course I can't remember what they looked like." E. B. has, of course, sculpted hundreds and hundreds of animals, and they are exceedingly persuasive as crystallization of the creature itself. "I never try for what you might call *portraits* of animals," E. B. says. "For the bears, you sculpt strength and walking, lumbering along. The presence of a bear. And for a rabbit, you sculpt its crouching, its intensity of looking at something. And you do *raccoonness* with a raccoon. And squirrels that have a lot of *squirrelness* about them, even though they may look only vaguely like a real squirrel. As long as you can capture the essence of the creature, you're in business."

Work, E. B. maintains, "is a very interesting occupation, but the result is *more* interesting. And I liked the activity [sculpting]; it's a very nice activity: I like the act of sculpture. And of course you have no memory of the activity." You go into a kind of trance? I ask him. "No, you just have no memory of the activity itself. For example, I can't remember doing *that* (he points at a female torso standing nearby, the buttery one in wood), though I can recognize it as mine."

For E. B. Cox, making sculpture is a highly intuitive procedure. "You have this dream image, a concept, in your mind. And then, as you work, you'll change that concept, if the wood or stone doesn't *accept* it. And you fit it in. You can change your mind, you see?" I point out that this doesn't seem all that remote from the procedures of the legendary Innu sculptors, whose task is to release the hidden subject from within the stone. "It's a similar thing," E. B. agrees, "except," he grins puckishly, "I don't get so mystical about it.

You start by cutting away the parts you don't need and it gets more intense as you get down to the point where you can see what you're getting!" You have to cooperate with the stone. You can't do with the stone what isn't there." I suggest that it must start to get pretty tense at this point, that this is where you could start to make mistakes. E. B. is, of course, remarkably undramatic about all this. "If the stone breaks," he tells me, the twinkle in his eyes growing calculably brighter, "you simply make *two* things."

I point out how exciting it must be to see a figure emerge under your hands. "Oh, yes," says E. B. reverently, "that's *it*. And, you know, I can't wait! I usually start work at seven o'clock in the morning and then not realize when I've been working steadily for five or six hours. Sometimes," he chuckles, "I even put off lunch!" And then, suddenly, his voice is filled with a new urgency, and you can see in his eyes that light that emanates from any fount of pure creativity. His words become deliberate, heavy, respectful of his own inner promptings: "It's because I want to see how it's going to turn out. It's as if it were something independent. It's not a question of how *I'm* going to turn it out, but rather how *it* is going to turn out. You're not always the master, here. You simply do your best to reveal your vision." Then, almost as if he's aware that he's sounding too much like an artist — an artist, furthermore, on the cusp of the theoretical (which he hates), E. B. gets that infectious E. B.-ish gleam of mischief in his eyes: "And if there's going to be any difficulty, *you change your vision!*" So much for mysticism.

E. B. is a bottom-line man. At one point in our conversation, he pushes up his sleeve and grasps his left forearm with his right hand. "All you have to know about sculpture," he tells me "is the fullness of your arm." His fingers encircle the musculature of the limb. "That is *the shape*. That's *human shape*. That's what you have to know, the fullness of it. It's not flat, it's bulging! It must be growth.

It must be organic." And it wouldn't be enough to try to depict this in two dimensions, in painting? "No, I like other peoples' paintings and drawings. But for me there must be this sense of knitting things, of growth. Like flowers. Paintings are illusions, dreams. Sculpture, by contrast, is real. Sculpture is mass. You can touch it. A sculpture can fall and hit you in the toe."

There was something else I wanted to bring up. And it had to do with the look of E. B.'s sculptures. With the stirring nobility of their features. It was something touching their sense of timelessness. "A good sculpture," says E. B., "never grows dated." There is an inadvertent play on words here. By never growing dated, he means, in the first place, that the look of a sculpture should be timeless, the features of a sculptural face having those generalized features that cannot be linked to a decade or even a century, but exist somewhere on a trajectory that arcs from the ancients to us. Some of Cox's sculptured faces possess a Greco-Roman look (he admires Greek sculpture enormously). Some of them have the brutal nobility of Pre-Columbian figures. But all of his sculpted visages somehow honour the prevailing dignity of humankind, their mouths set in resolution, their eyes rapt with an inner steadiness and a fixed gaze that reaches towards forever.

At a more sublunary level, he also means, more particularly, that, given the generalized nature of his work, he doesn't assign any chronological date to any of his works. He signs them, yes, but he won't date them. All of his sculptures live in an eternal present.

"A sculpture," says E. B., with the sonorous finality of which he is superbly capable, "is there *all the time*."

Gary Michael Dault

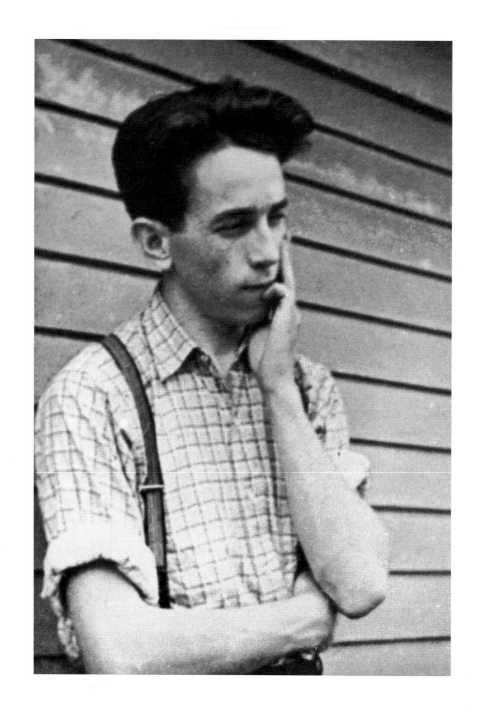

E. B. Cox at age 21

Kathleen Coburn, E. B. Cox, Hugh O'Connor, John Hall at Palgrave - 1953

Chronology

1914 Born in Botha, Alberta, the second son of John and Eva (Tabb). John Cox had moved to Alberta to help create a dairy industry in that province.

1921 Moves to a family farm near Bowmanville, Ontario. Begins whittling and is inspired by his grandfather's woodcarving.

Early **1930s** As a high school student, he visits newly expanded Royal Ontario Museum and is impressed by the motifs in the great Haida totem poles incorporated there. Starts to carve small totem-like wood pieces, which are sold at Eaton's College Street store in the Canadian handicrafts corner.

1934–38 Attends Victoria College, University of Toronto; studies German and French languages. After attending the German lectures of Professor Barker Fairley, becomes a frequent guest of Fairley and his wife at their North Toronto home. Through the influential professor, Cox becomes acquainted with a large circle of artists, including members of the Group of Seven. Cox eventually meets members of the Sculptors' Society of Canada, such as Elizabeth Wyn Wood, Emanuel Hahn, Francis Loring and Florence Wyle.

1938 Attends College of Education, Toronto, to become a teacher.

1939 Begins teaching languages at Upper Canada College, Toronto.

1939 Takes canoe trip to Whitefish Falls, north of Manitoulin Island, with A. Y. Jackson, Barker Fairley and John Hall, Barker Fairley's son-in-law and the art teacher at the Upper Canada College Preparatory School; at this time, he learns of the outbreak of Second World War.

1942–45 Serves with Canadian Armed Forces in France, Italy and Holland, and becomes a translator for the debriefing of prisoners at the end of Second World War. In the course of his service overseas, he is exposed to great art treasures of Europe and meets English sculptor Henry Moore. His fluency in French, German and Italian prove valuable and he is duly decorated for his war service

1945–50 Resumes teaching languages at Upper Canada College. Interest in sculpture increases while interest in teaching diminishes.

1947 Joins Ontario Society of Artists (OSA) and Sculptors' Society of Canada, and begins to exhibit in group shows.

1948 Marries Elizabeth Campbell and they have two daughters, Kathy and Sally.

1950 Moves to farm at Palgrave, Ontario, and takes up sculpture as a full-time career.

Early **1950s** Pioneers the use of compressed-air chisel and other power tools in creating sculpture. This technique enables him to create large-scale installations of sculpture single-handedly. Cox is awarded architectural commissions at several

schools, libraries and other public institutions. Takes part in group and solo exhibitions of the OSA and frequently serves as a juror for their competitions. Begins to participate in group and solo shows at various private galleries, including the Roberts Gallery, Toronto, a major dealer of Cox's work for the next sixteen years.

1954 Moves to a property at Bayview and Finch Avenue, at that time still farmland, north of Toronto.

Late **1950s** Artistic output shifts from architectural decoration to works of all sizes for public and private collections.

1958 The abstract *Draped Figures* is erected at Victoria College, University of Toronto.

1959 *Spring Break-up* fountain is installed at the Park Plaza Hotel, at the Avenue Road entrance.

1959 Receives an architectural commission from Venchiarutti and Venchiarutti to create a ceramic relief, ninety-nine-and-a-half feet long, depicting fish, trees and flowers, to adorn the tellers' counter at one of Bank of Nova Scotia's new and modern branches (106 Yonge St.).

1960s–70s Travels include trips to Greece, Italy and the West Coast of Canada.

1960 Creates the *Great White Lady*, which is installed at McMaster University, Hamilton, Ontario.

1962 Receives commission to create outdoor sculpture for the Ernest C. Drury School for the Deaf at Milton, Ontario, and sculpts seven large animal sculptures designed for touching and climbing.

1963 Conceives of an idea for a summer attraction at the Georgian Peaks Ski Resort. E. B. Cox proposes to sculpt nine massive figures from Greek mythology and install them on the slopes for the enjoyment of summer visitors. He eventually goes on to create an installation of twenty-one pieces and names it *Garden of the Greek Gods.*

1965 Receives a commission to sculpt a stone entranceway at Glendon College, York University.

1967 *Seated Lady* is commissioned and placed at the Brampton Court House.

1967 An artistic storm is generated when Secretary of State Judy LaMarsh rejects E. B. Cox's model for a ten-foot red stone sculpture of former Prime Minister R. B. Bennett despite heavy support from the selection committee and the National Gallery of Art in Ottawa. It is felt that Cox's rendering of Mr. Bennett is not conservative enough to suit the Minister. Ultimately the maquette is obtained by the National Gallery.

1970s Creates a group of sculptures on a Canadian youth and environment theme sponsored by Canada Dry and eventually donated to Canadian National Exhibition.

1974 Executes twenty-one Canadian animal figures for the Niagara Fall Public Library and later does seven *Totems of the Tuscarora Tribe* for installation at the Lewiston Public Library in Lewiston, New York.

1978 A monumental limestone bear, a favourite Cox subject, is installed at the Guild of All Arts, Scarborough.

1979 *The Garden of the Greek Gods* is exhibited at the Royal Winter Fair and later moved to a permanent site on the grounds at the Canadian National Exhibition.

1983 At the age of sixty-nine, Cox moves to a "farmhouse" built in 1870 on Broadview Avenue in Toronto and sets up studio facilities in the former bakery wagon stables, then proceeds to produce great numbers of sculptural pieces of all sizes, for scores of significant collectors.

1983–present Cox travels to Europe on a number of trips to Italy and Greece and sculpts at an atelier in southern France. Remarkable output continues and every piece is acquired by collectors. At the age of 85, E. B. Cox still actively sculpts.

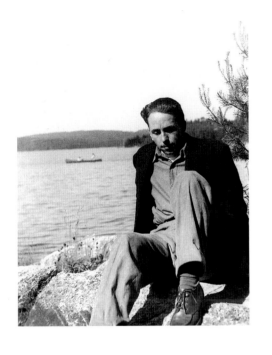
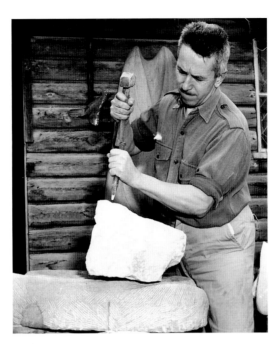
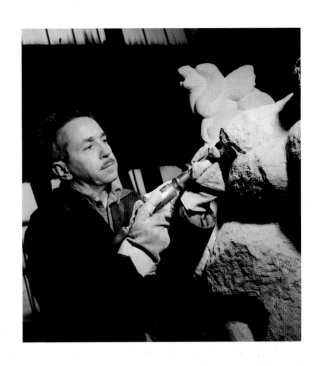
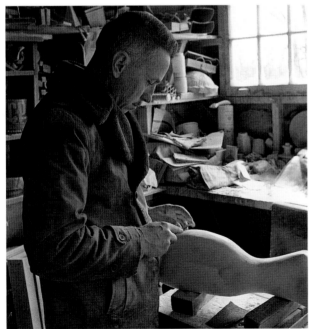
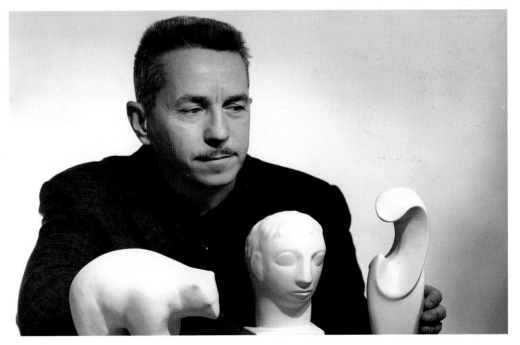

*"In August of 1960, McMaster University asked
me to create a sculpture for the north side of their
new Student Centre that would be massive,
powerful, and yet serene.
I started with a nine-ton chunk of white magnesium
limestone selected from the Renfrew Quarry and by
December 1960 the figure which had been reduced by then
to 7 tons was installed at McMaster University. The Great
White Lady was moved to a more verdant setting on the
south side of the Student Centre because some thought
it would look better there and others thought her
ample profile might have distracted the fledgling
theologians at the nearby divinity school."*

E. B. Cox

CREATION OF THE GREAT WHITE LADY

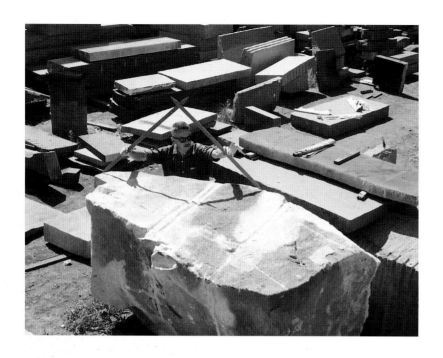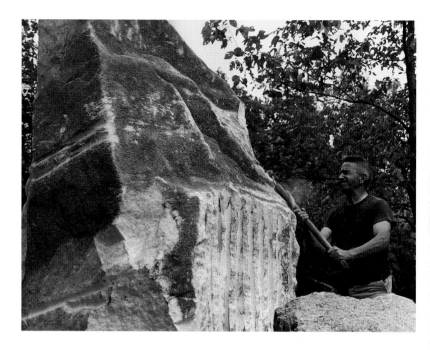

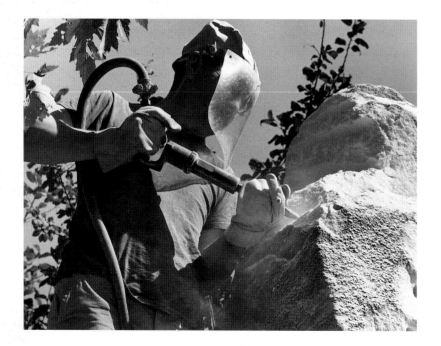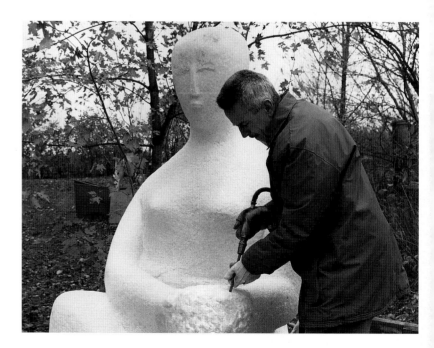

Creation of the Great White Lady

Roughing out the basic shape (following pages)

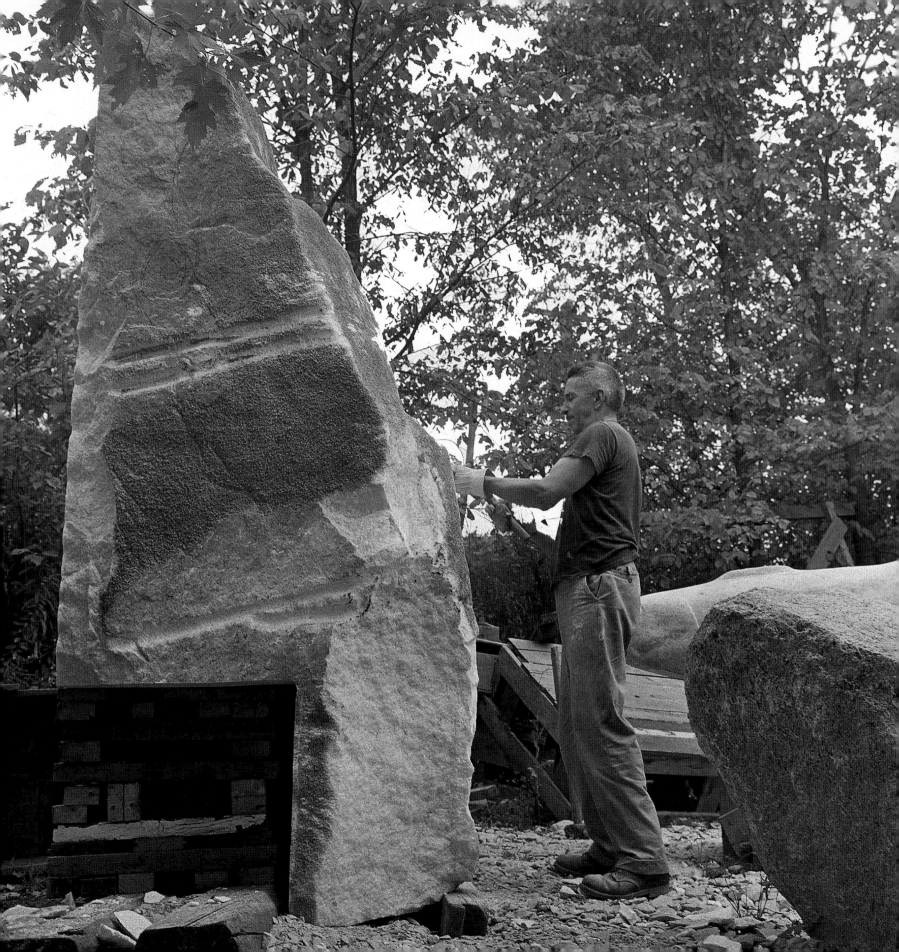

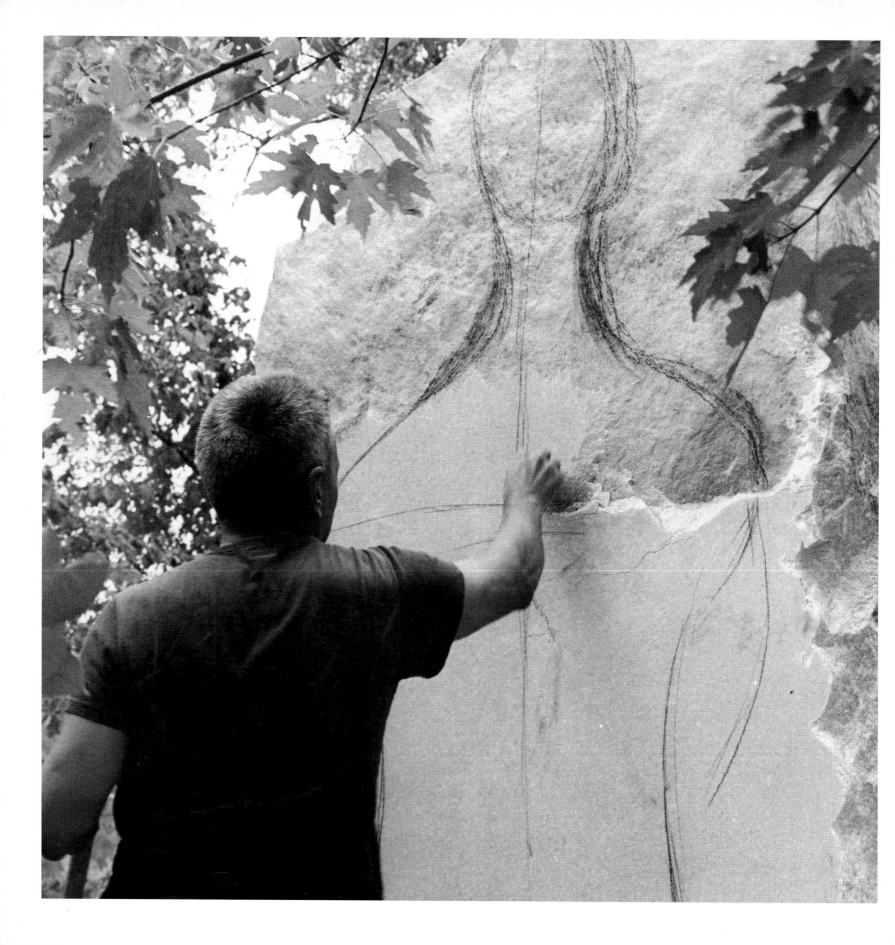

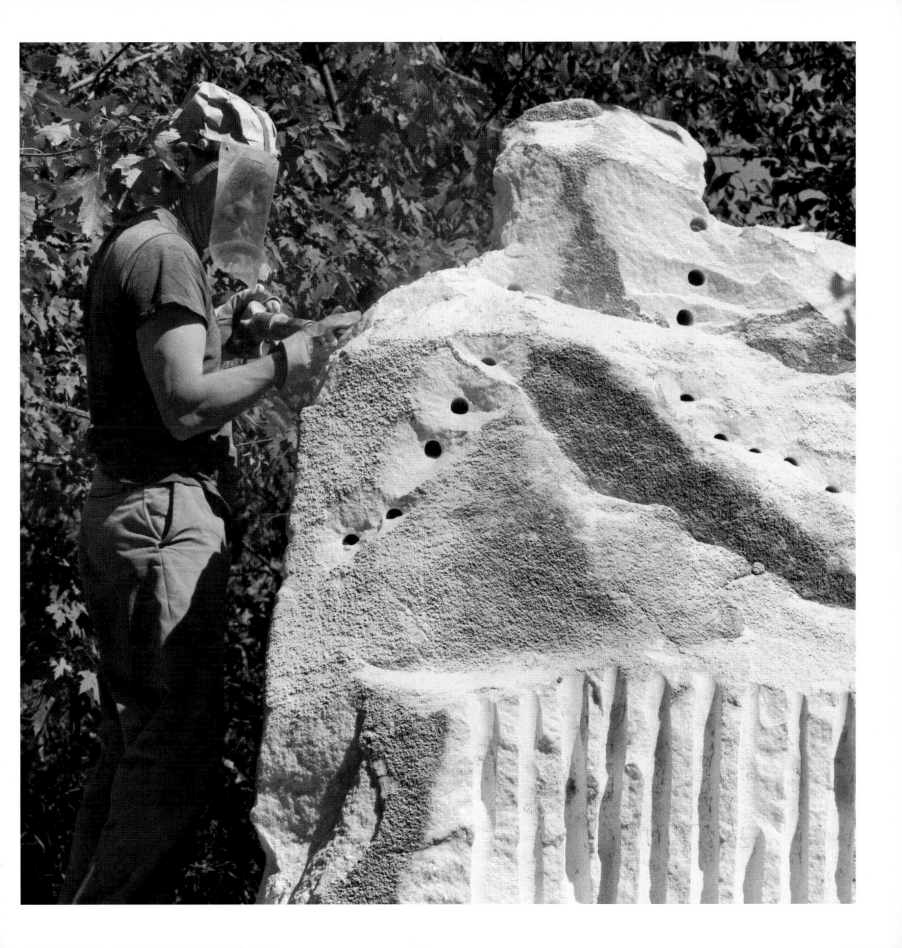

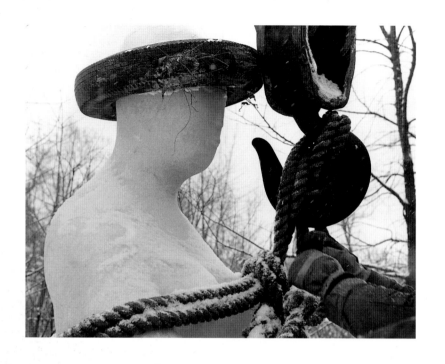

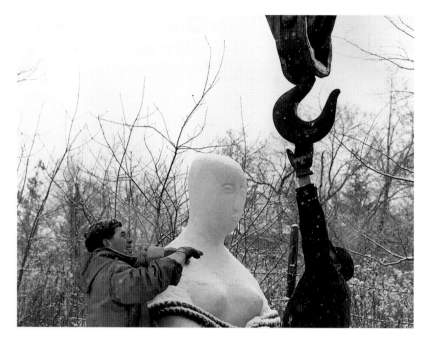

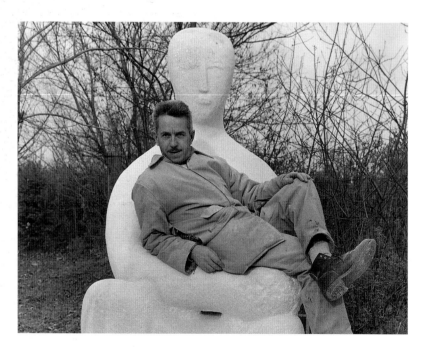

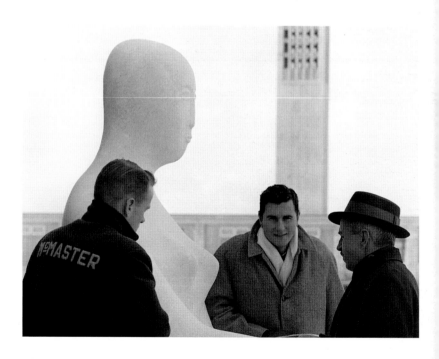

Installation at McMaster University

E. B. Cox revisits the Great White Lady

28

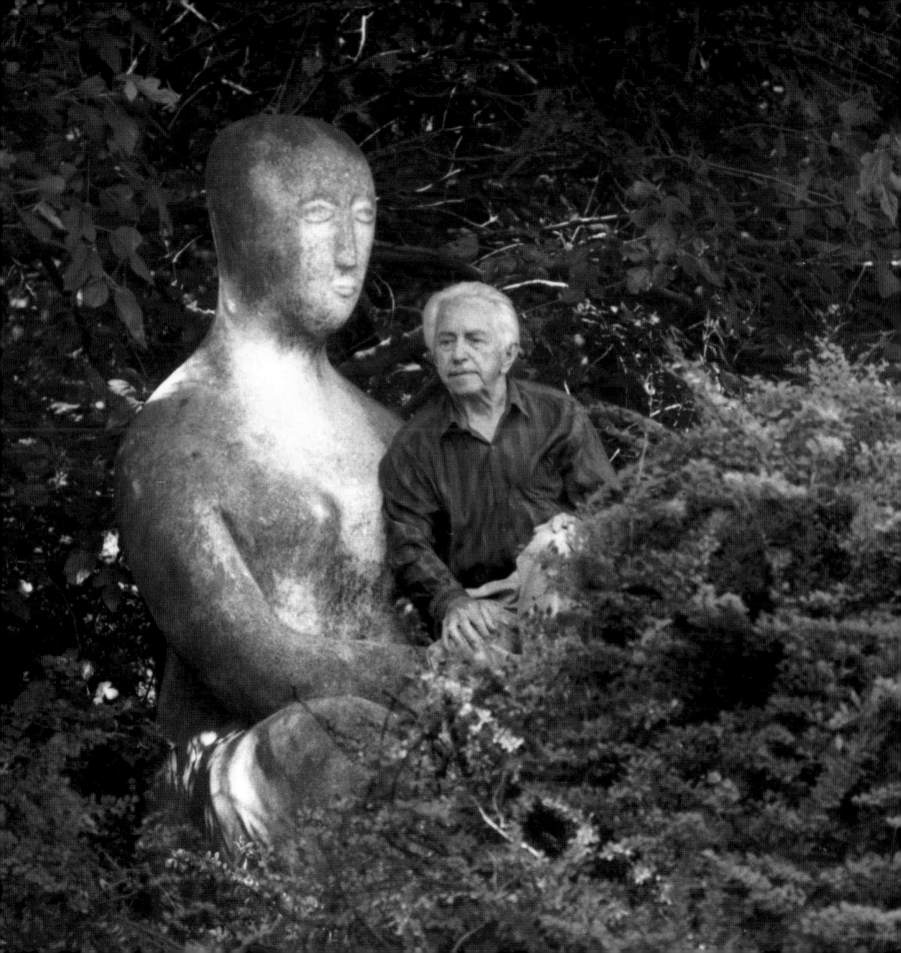

*"This spectacular commission
was a tourist attraction for a ski resort,
intended to be an experience both winter and
summer. To ride the lift to see the view over
Georgian Bay and to see the seventeen huge stone figures
from Greek Mythology was quite the thing to do!
Since then they've been moved and you can
find them at the Canadian National Exhibition
grounds. I've since added to the group and
there are now twenty-five figures in all. I created
all of them without any assistance from
anyone, by making use of air tools
rare at the time."*

E. B. Cox

GARDEN OF THE GREEK GODS

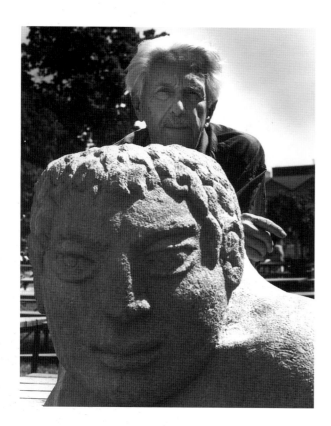 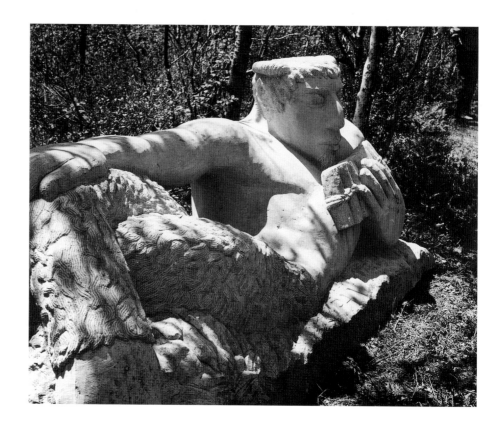

Return to the Garden of the Greek Gods, 1982

Pan

The Three Graces

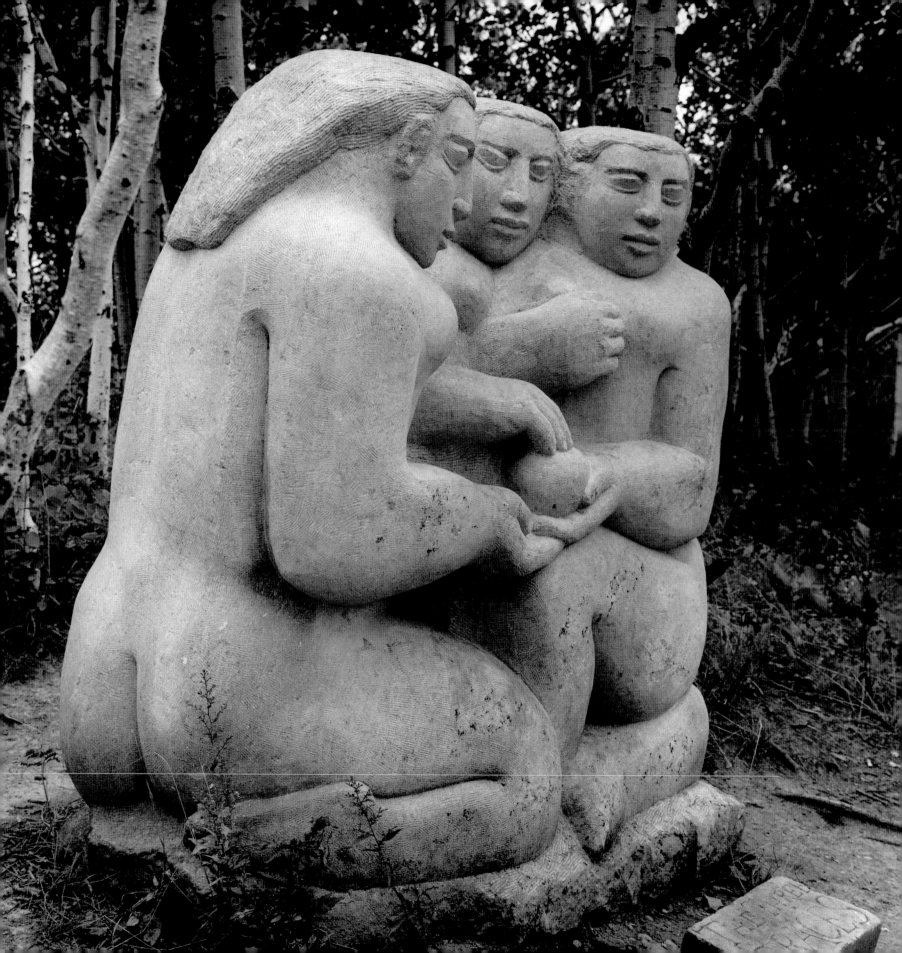

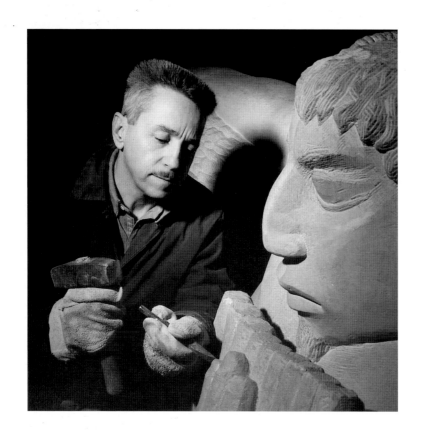

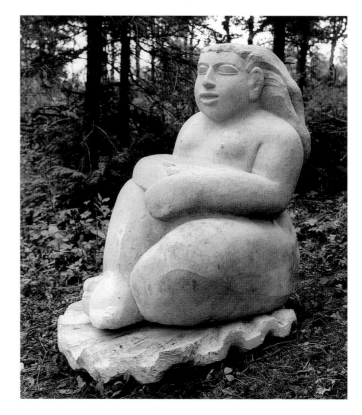

Perfecting Pan

Venus

Centaur

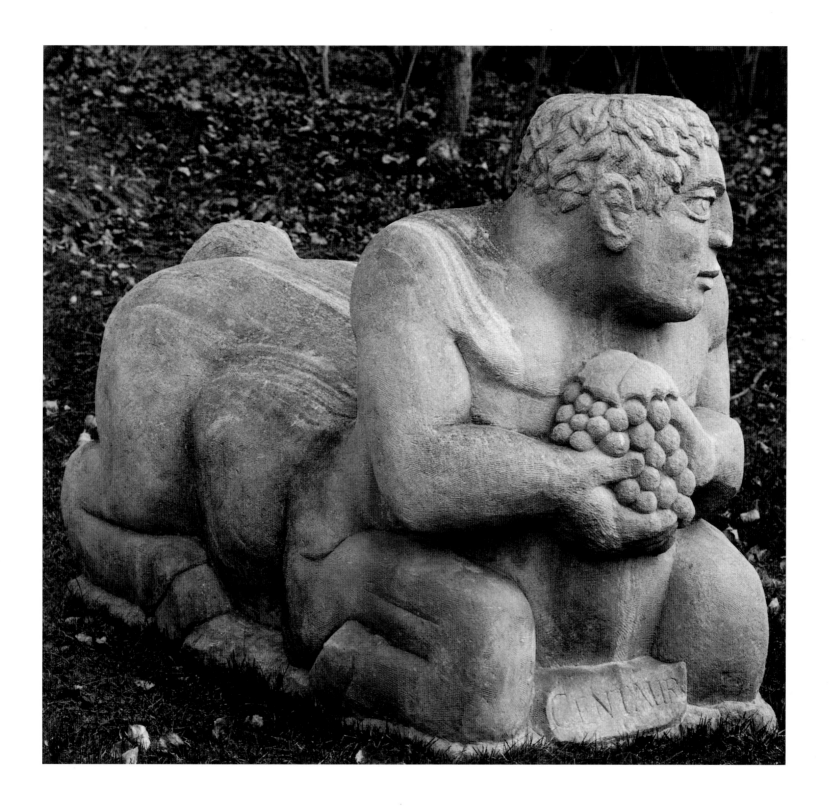

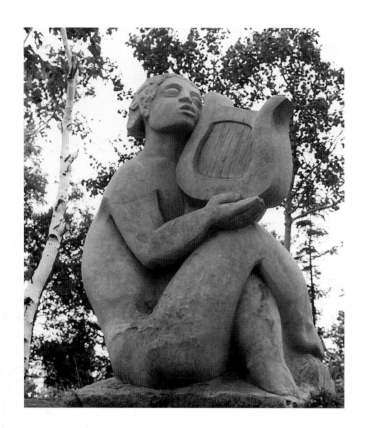 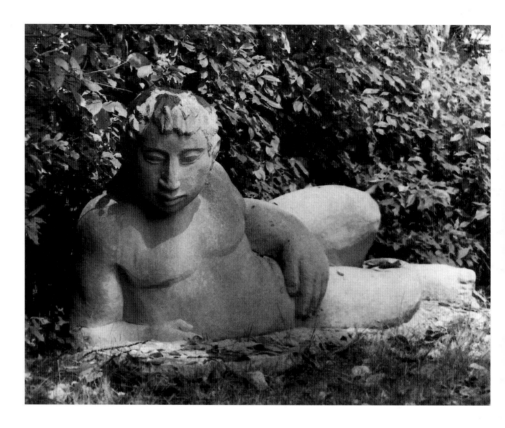

Orpheus

Narcissus

Hercules (two views)

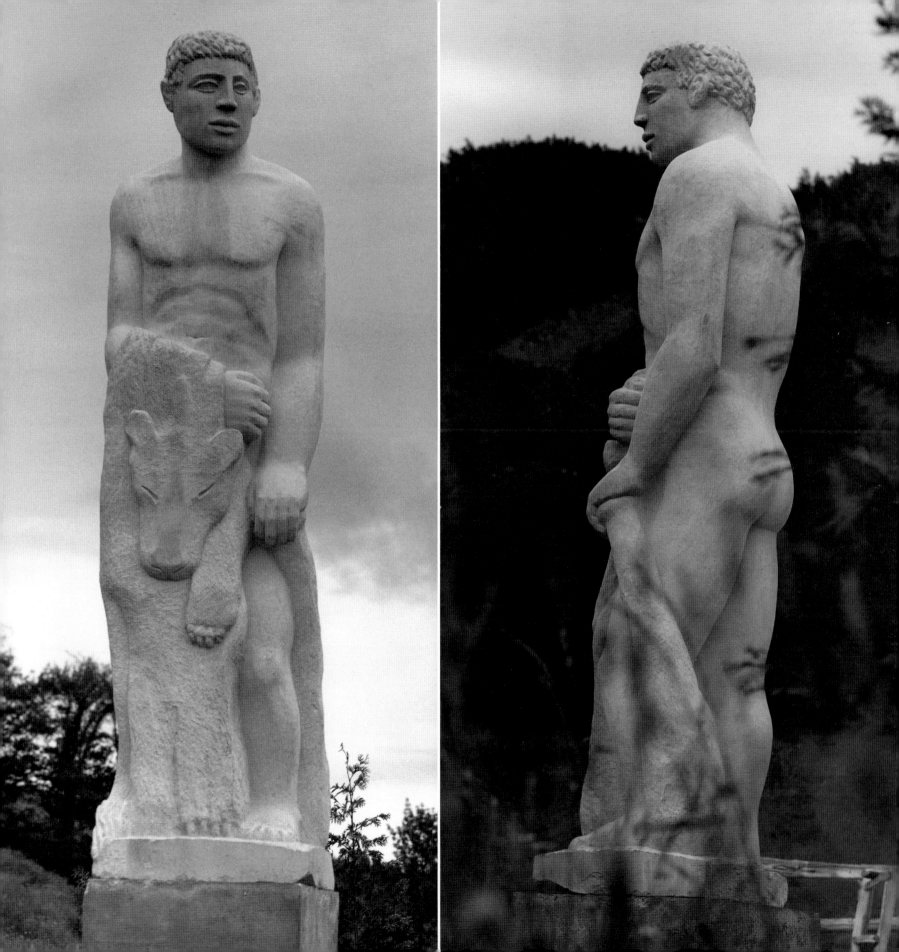

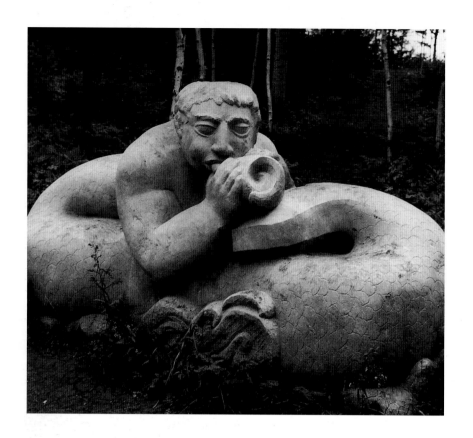

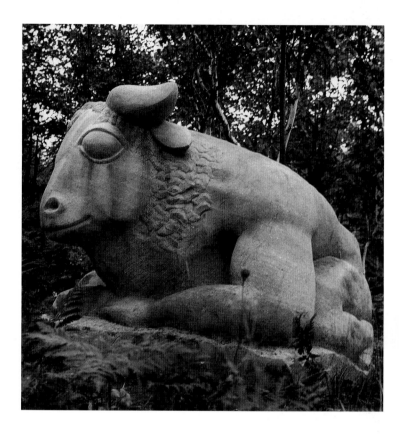

Triton

Minotaur

The Sculptor and Medusa

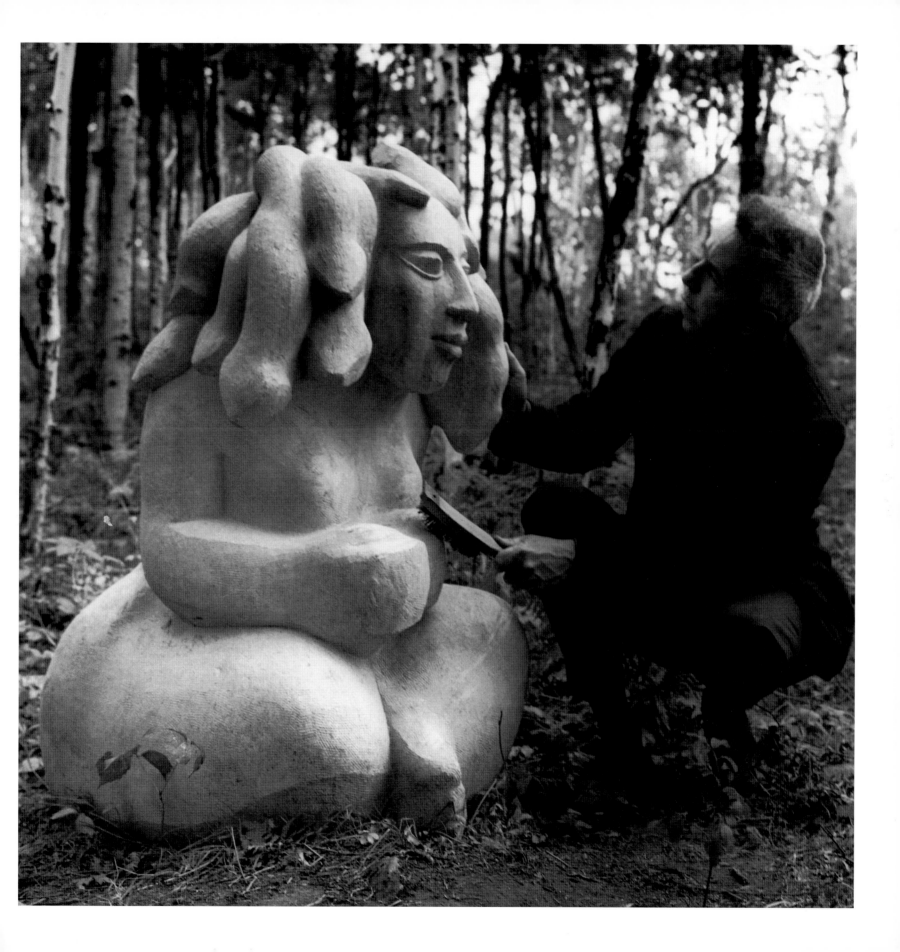

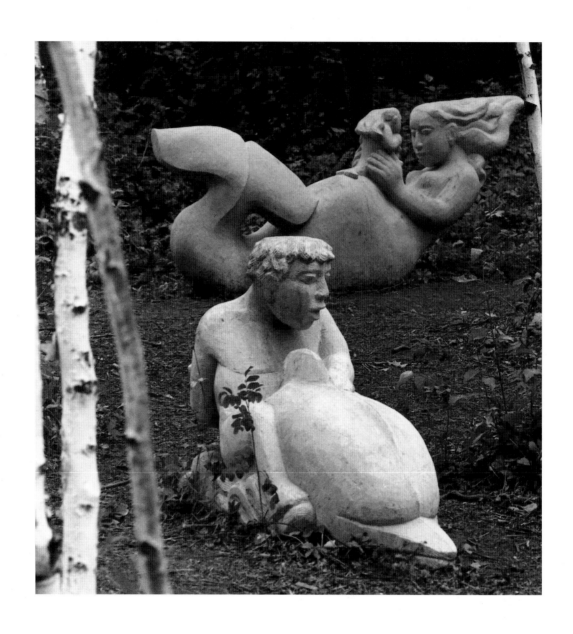

Mermaid with Child and Boy on Dolphin

Mermaid with Child (detail)

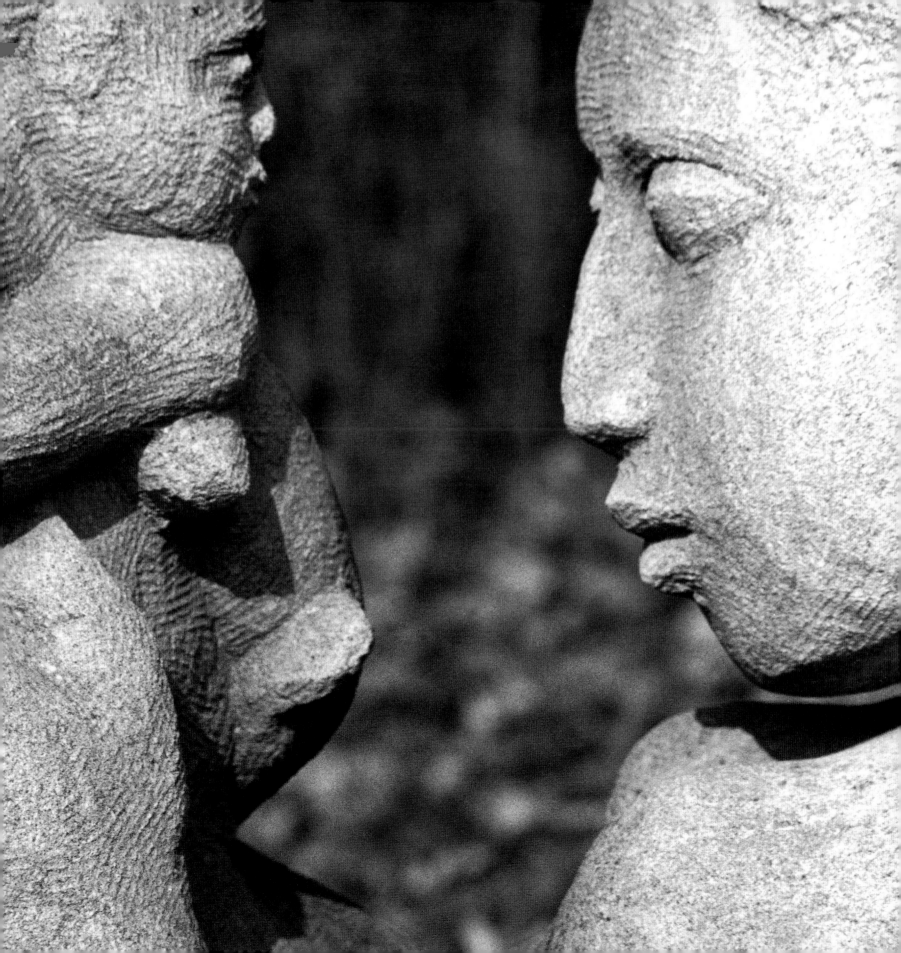

*"It is safe to say that anyone
who has lived in or visited the
Toronto area has experienced the
pleasure of viewing E. B. Cox's sculpture.
The pieces are everywhere and many
people have enjoyed them for a lifetime
without realizing who created
these wonderful works."*

Wendy Ingram

EARLY WORK AND INSTALLATIONS

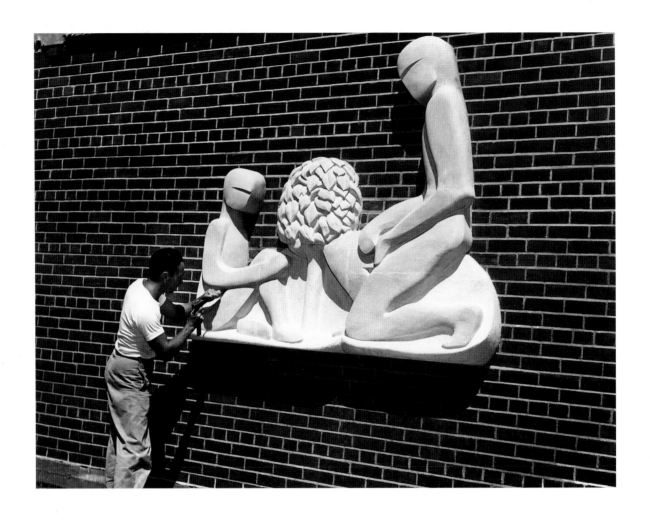

Learning and Nature, 1952, Limestone

Bird Bath, 1964, Limestone and Iron

After the Bath, 1970, Limestone

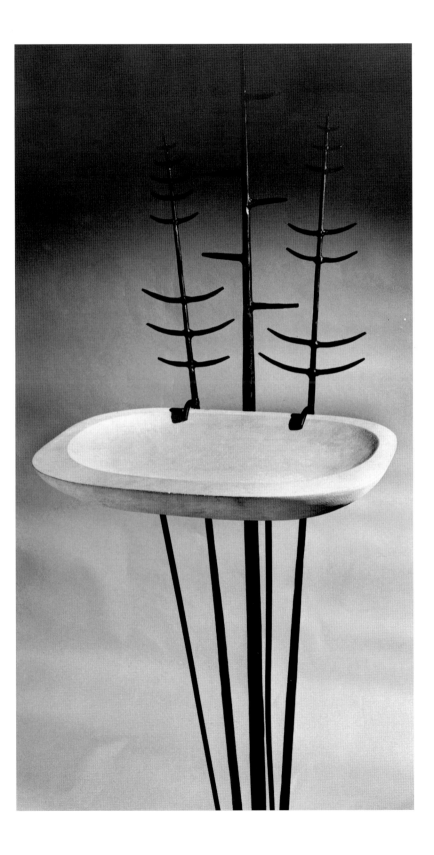

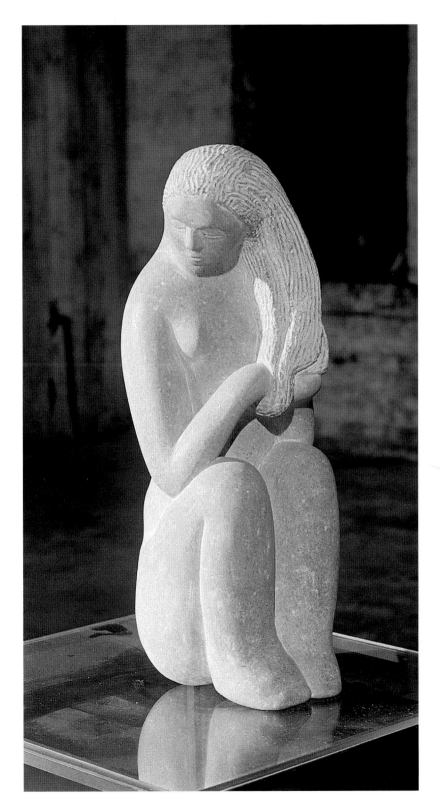

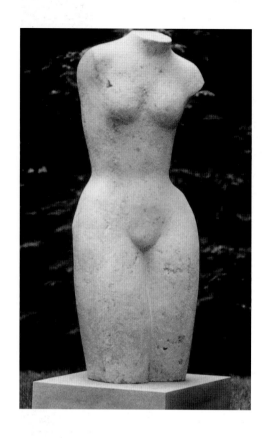 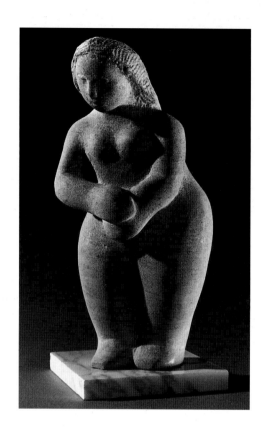 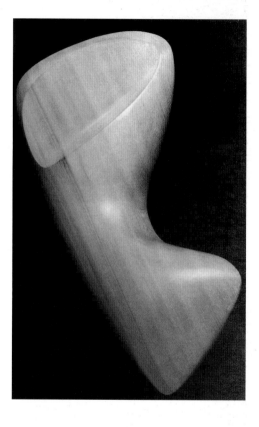

Torso, 1962, Limestone

Standing Woman, 1968, Limestone

Abstract Form, 1960, Marble

Height of Flags, 1960, Limestone

Torso, 1972, Limestone

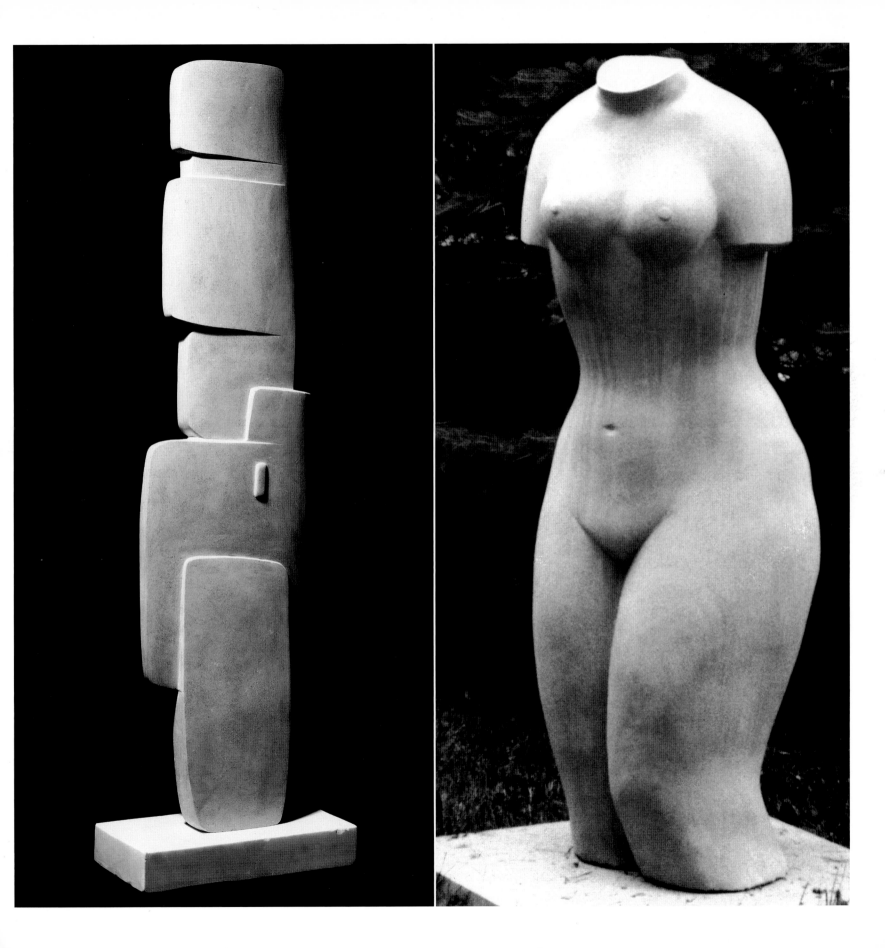

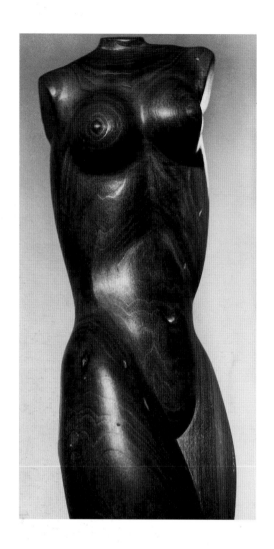 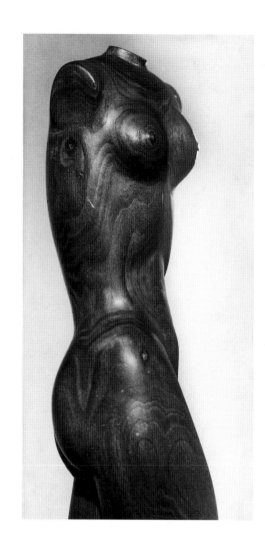 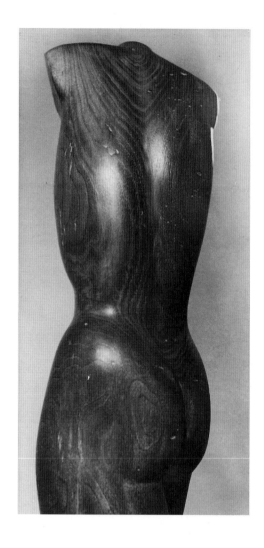

Rotation of Torso, 1961, Black Walnut

Three Boys Fountain, 1964, Limestone

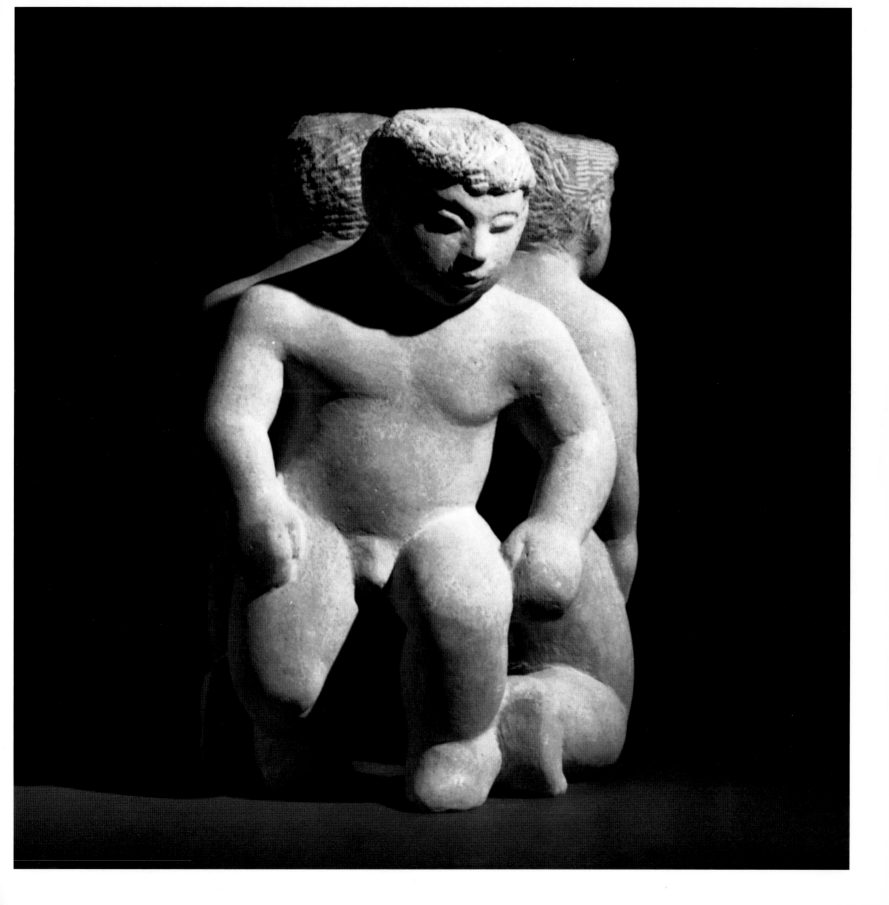

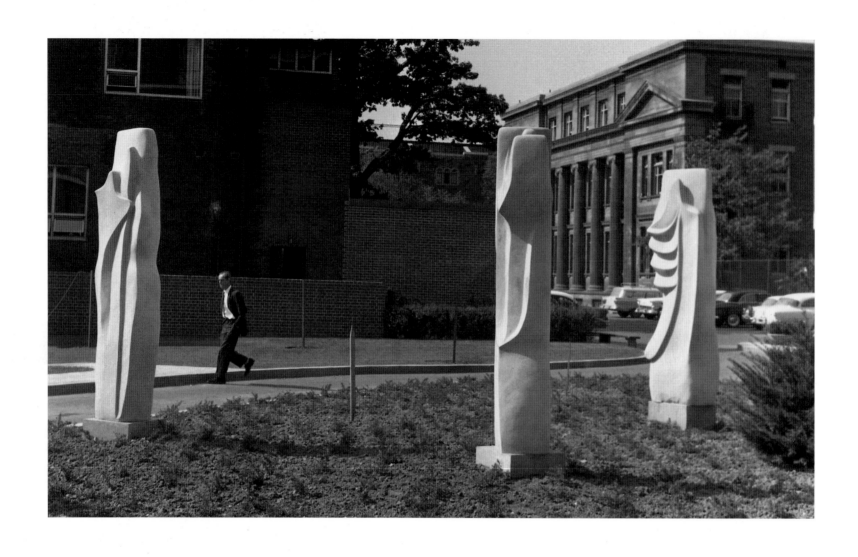

Draped Figures, Victoria College, 1958, Limestone

Seated Lady, Peel County Court House, 1967, Dolomite and Granite

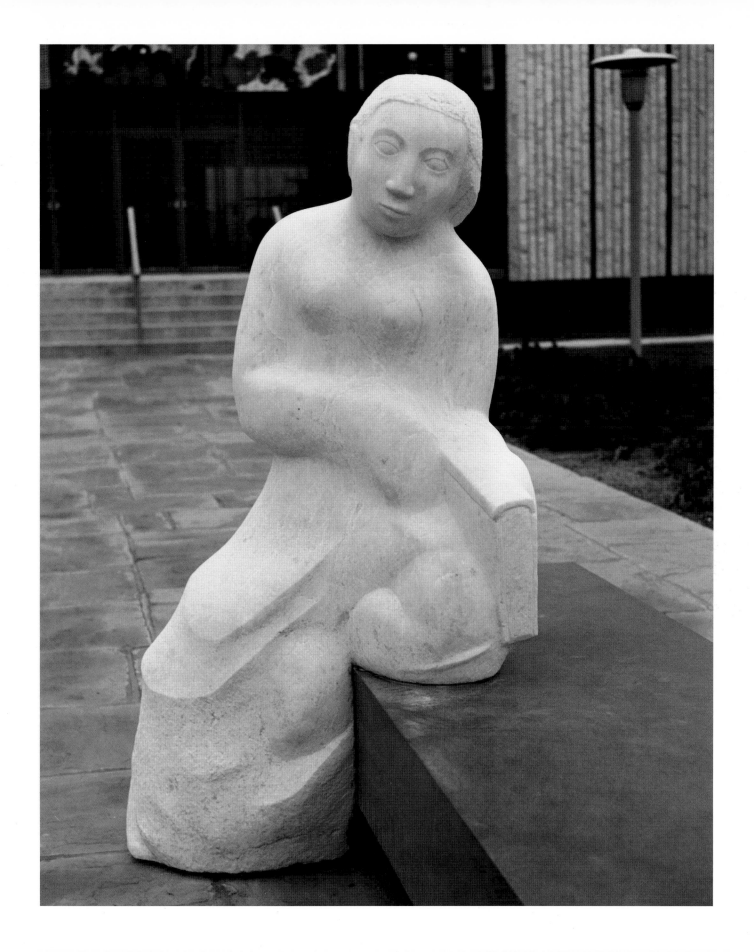

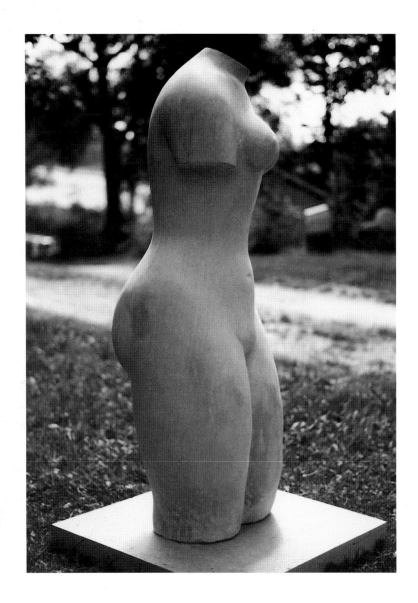
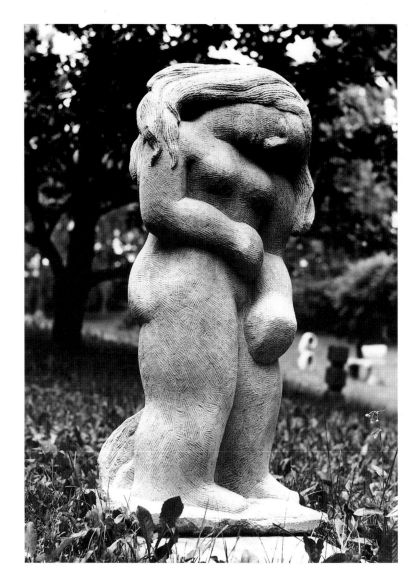

Torso, 1972, Limestone

The Listening Girl, 1972, Pink Feldspar

Mother and Child, 1956, Limestone

*Dedicated to the Lombard Insurance Chair in Paediatric
Research at the Hospital for Sick Children, 1998*

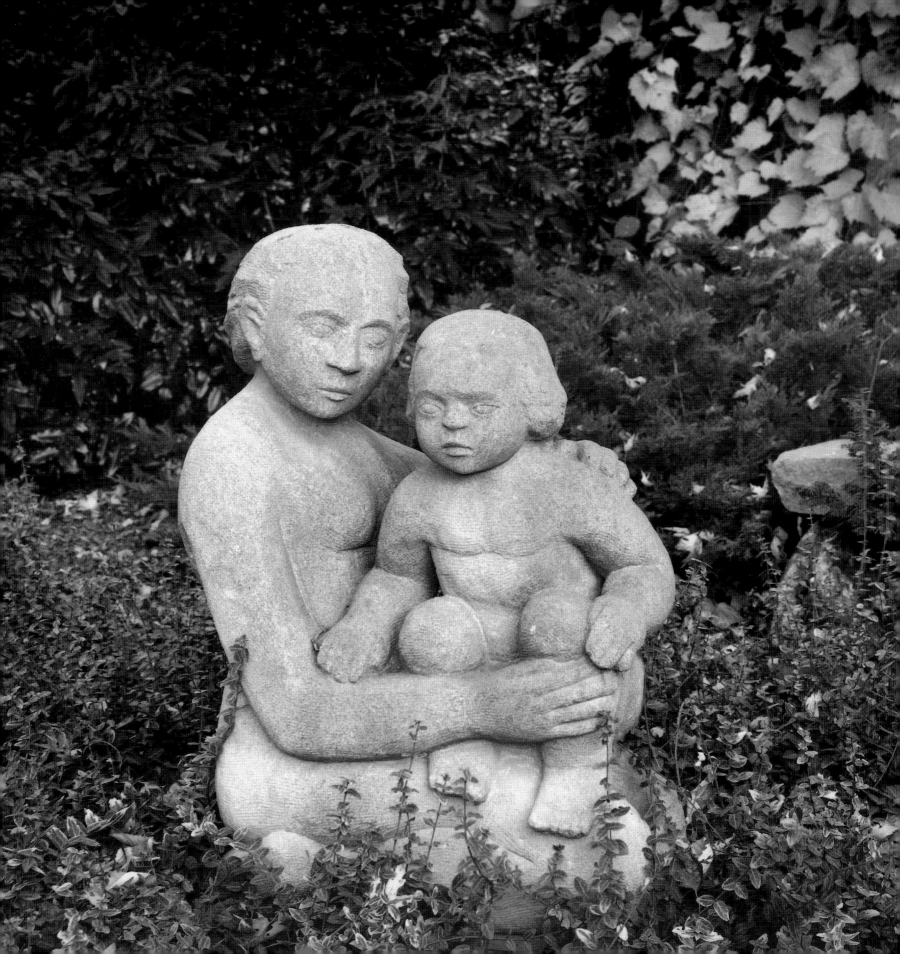

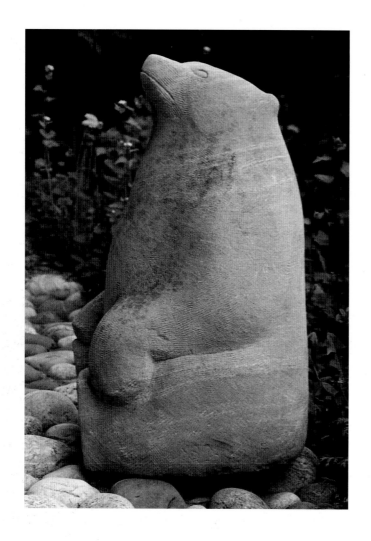

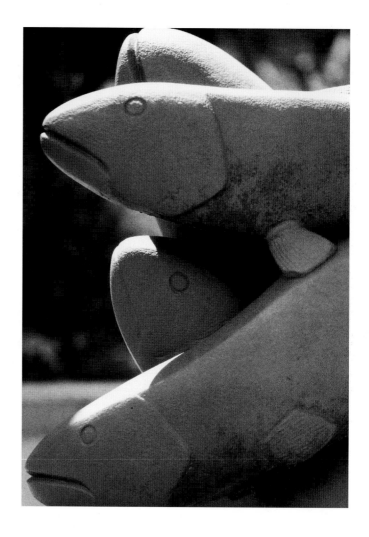

Bear, 1966, Limestone

Spring Break-up, Park Plaza Hotel, 1959, Limestone

Deer at Water, 1962, Limestone

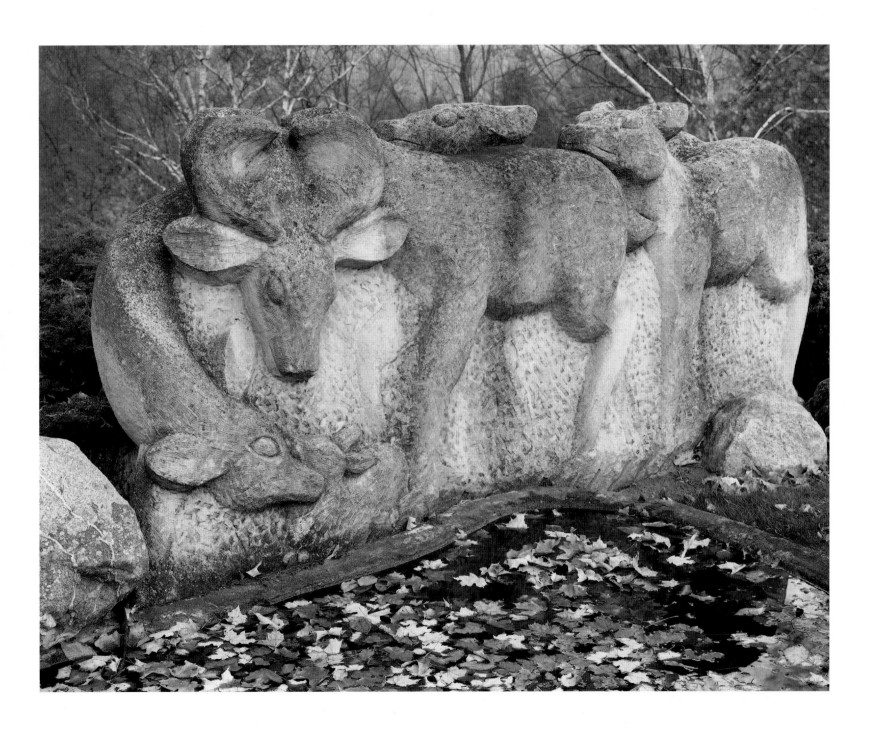

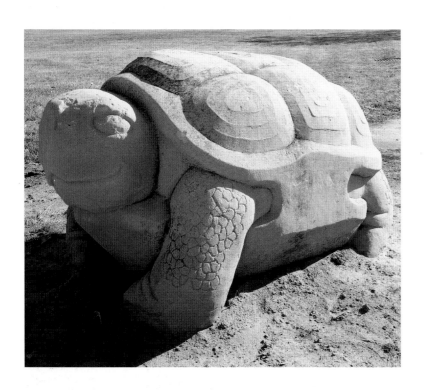 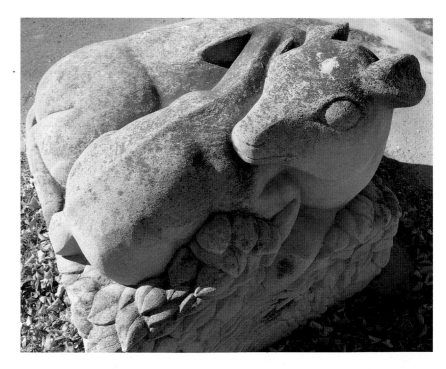

Ernest C. Drury School for the Deaf, Milton, Ontario

Tortoise, 1962, Limestone

Deer, 1962, Limestone

Buffalo and Mountain Goat, 1962, Limestone

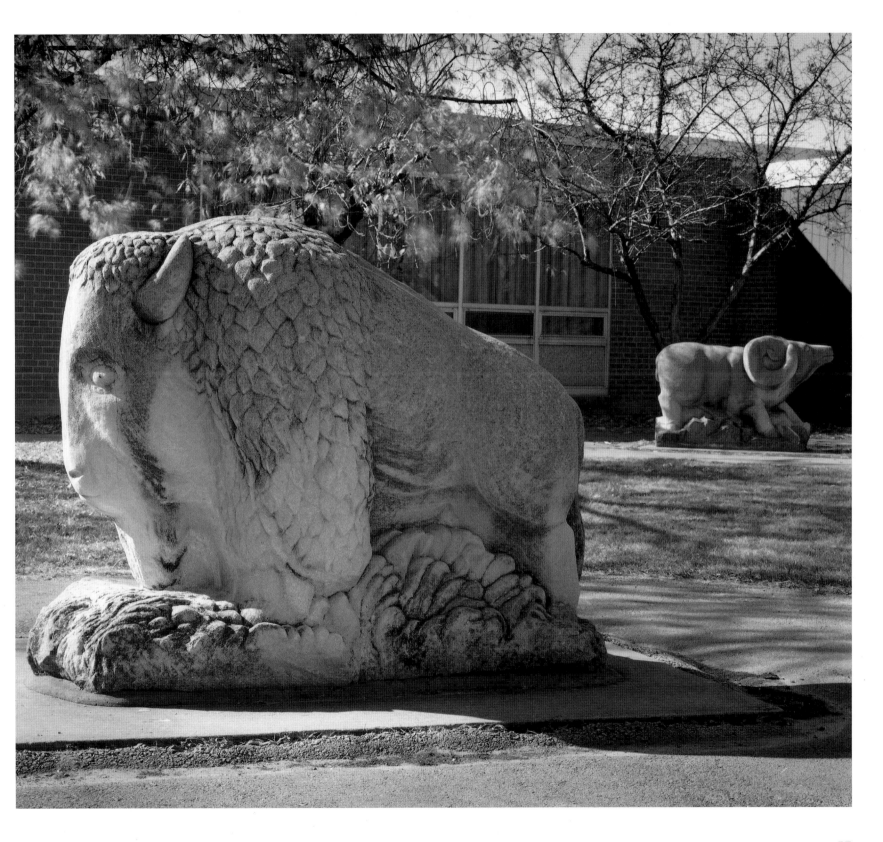

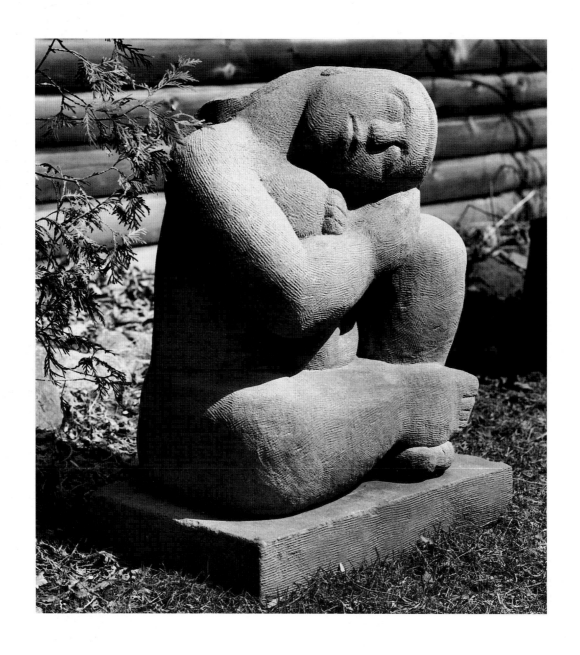

Aurora, 1973, Limestone

Garden of the artist at Finch and Bayview, 1960–70

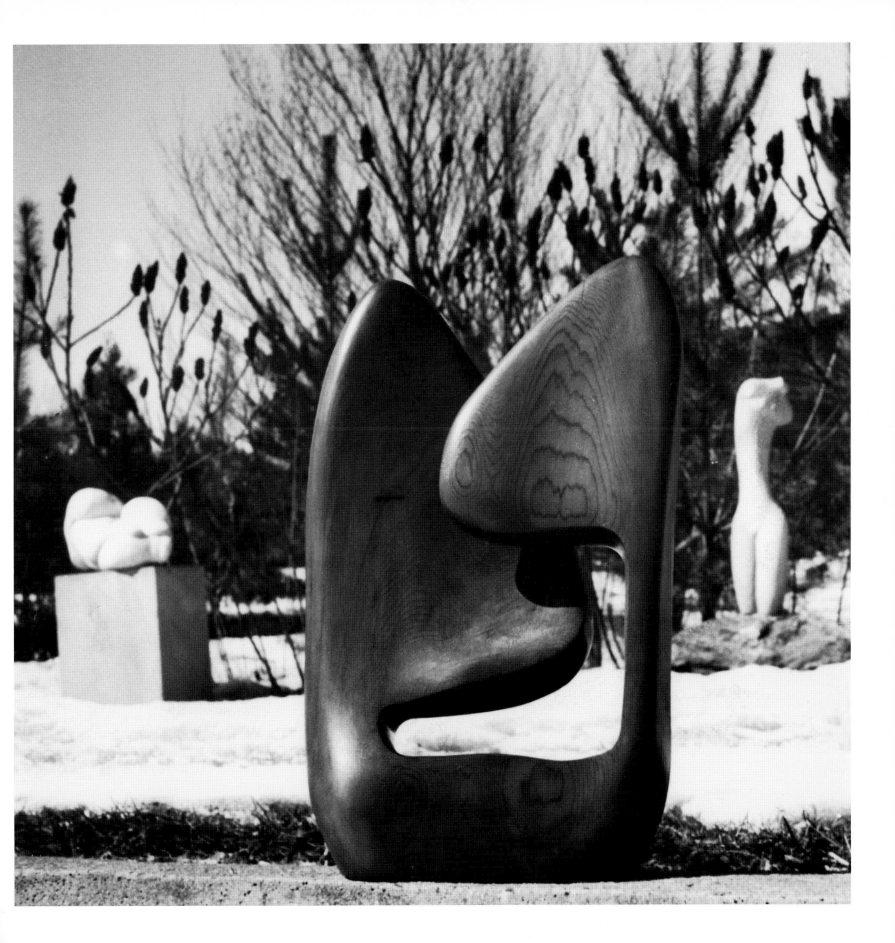

*"In the 1950s, the only
sculpture around Toronto was
monumental and important.
When the coffee table became popular
I began creating small, appealing
sculptures for people to place on
these tables. I think I was the first
sculptor in Toronto to invent
unimportant sculptures."*

E. B. Cox

FROM THE PRIVATE COLLECTIONS

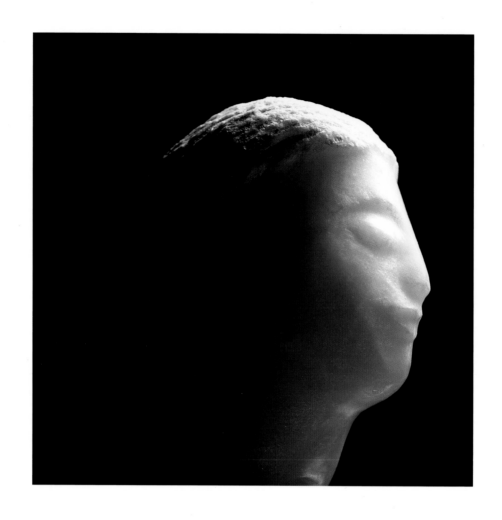

Small Head, 1986, Alabaster

Girl Looking Down, 1996, Dolomite

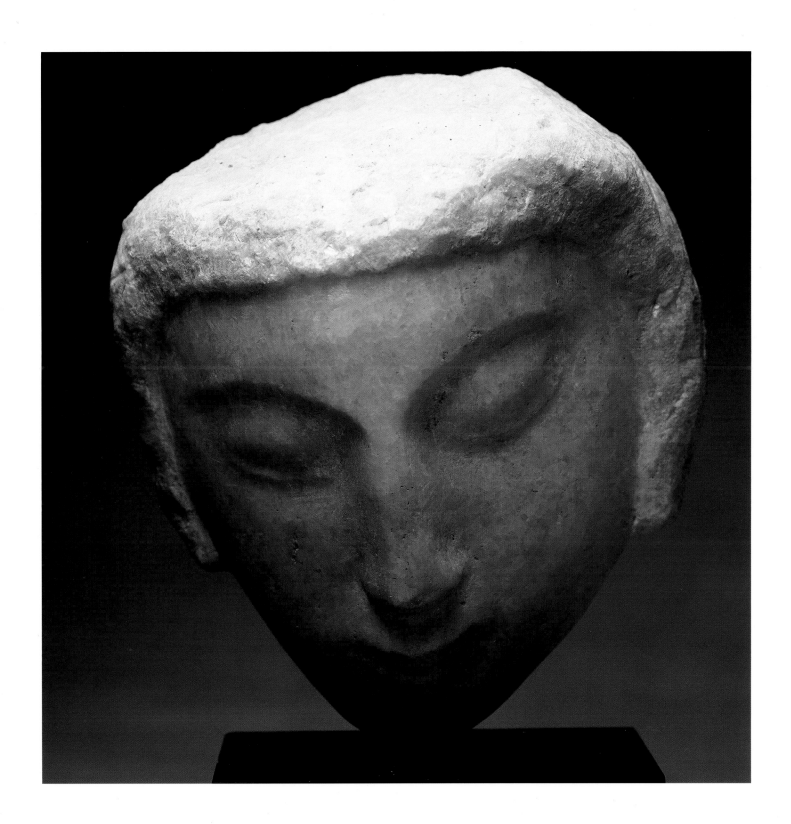

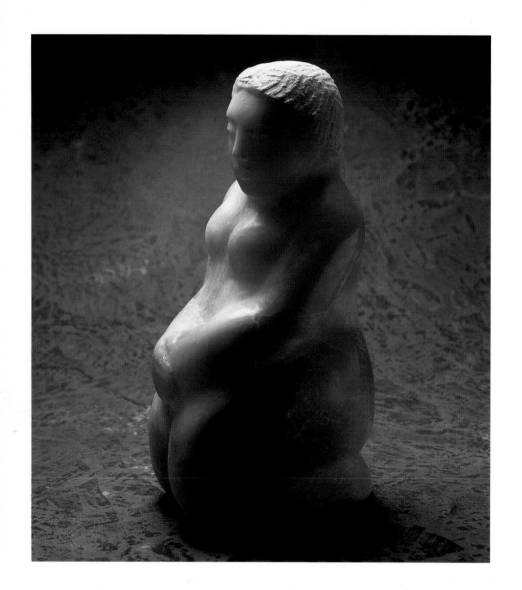

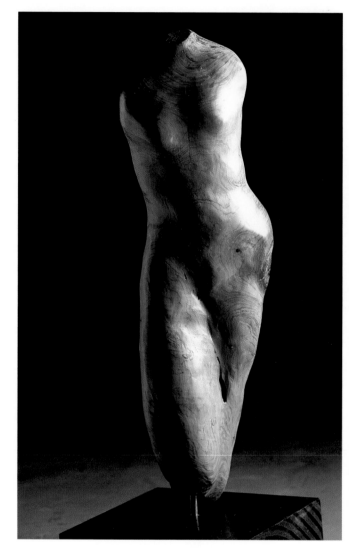

Kneeling Female, 1976, Alabaster

Torso, 1981, Cedar

Classic Head, 1985, Dolomite

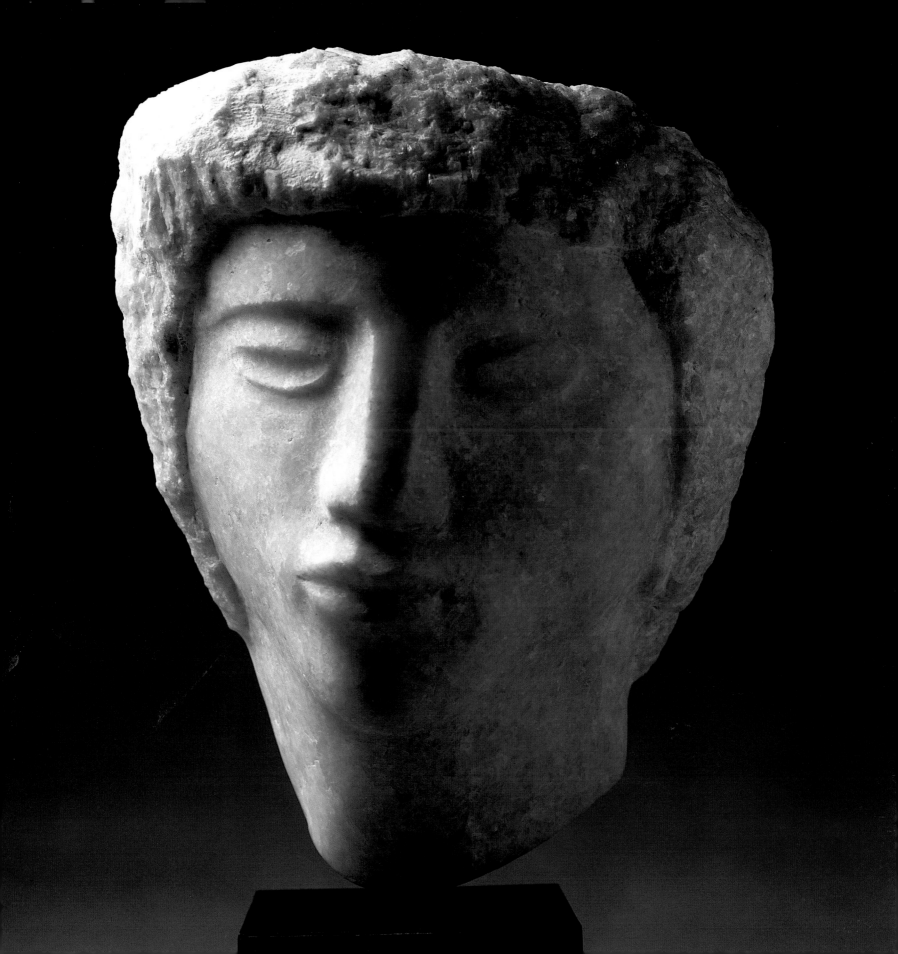

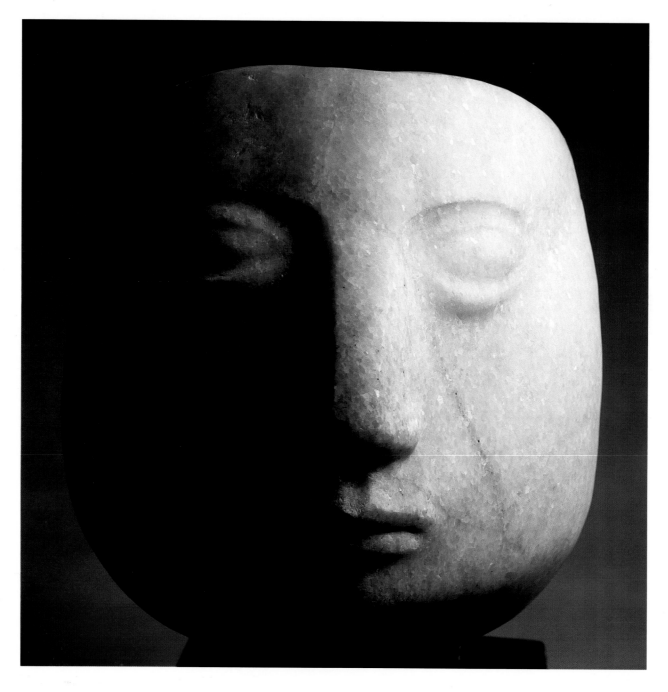

Moon Face Mask, 1975, Dolomite

Earth Mother, 1982, Alabaster

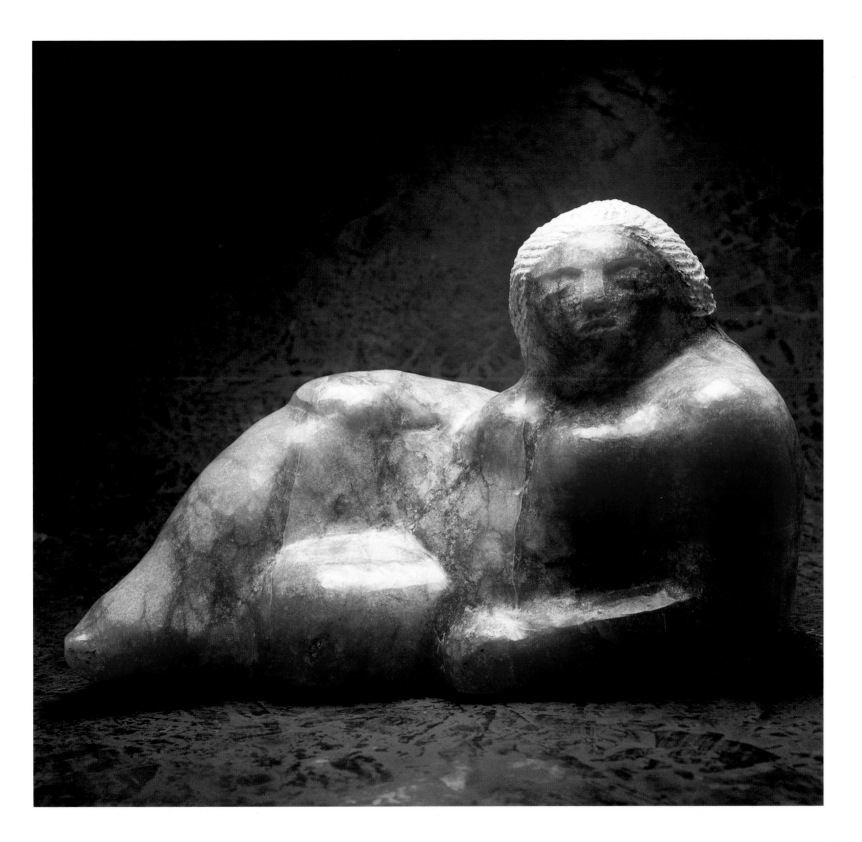

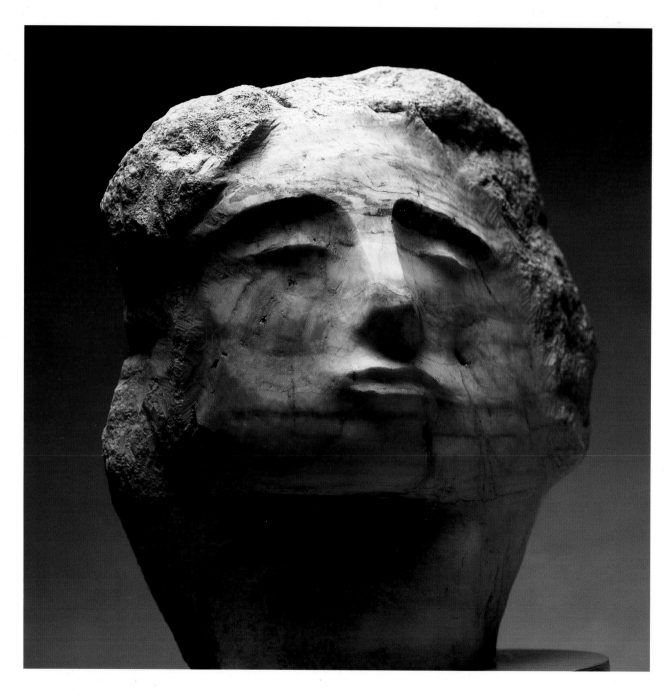

Woman Facing Wind and Detail, 1995, Alabaster

Seated Torso, 1976, Limestone (next page)

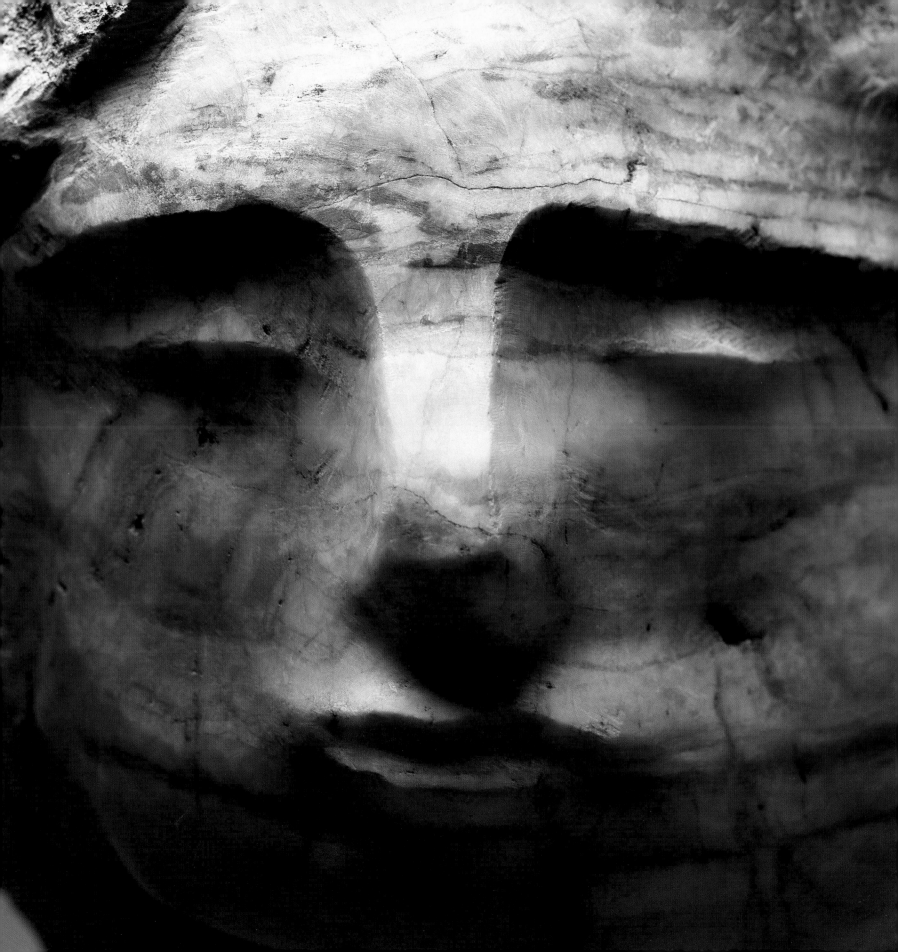

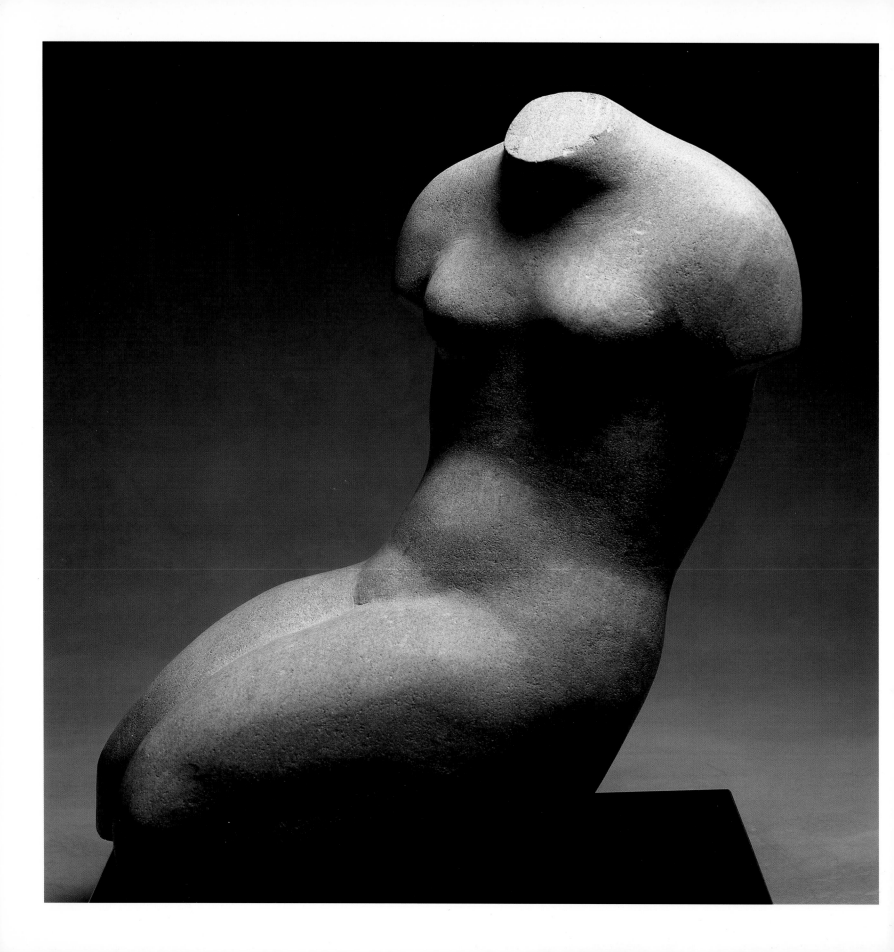

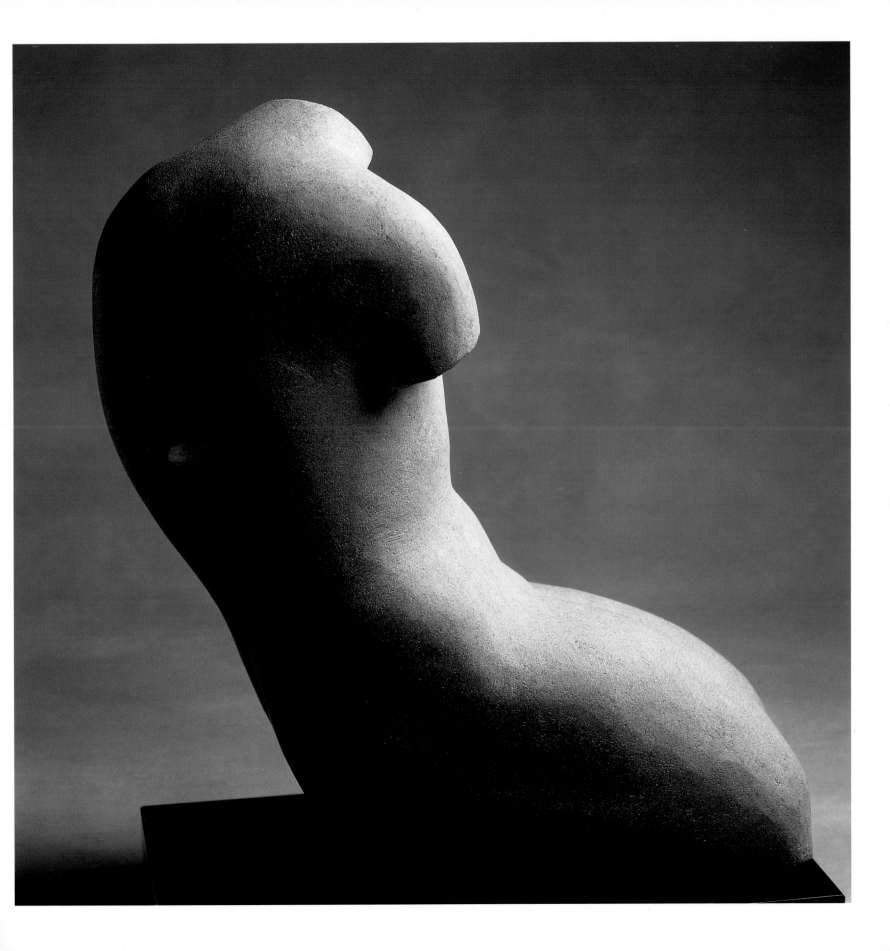

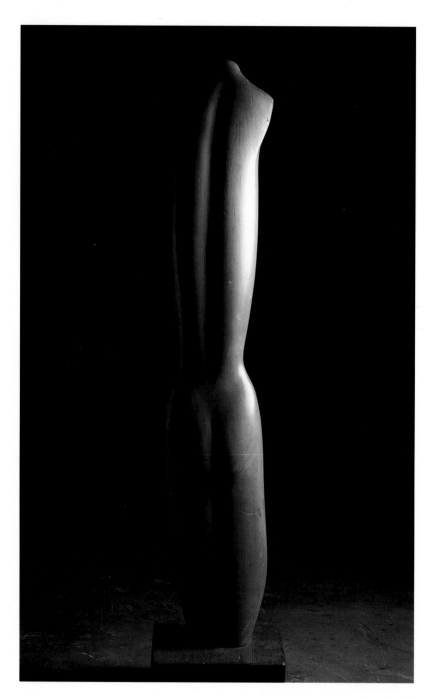

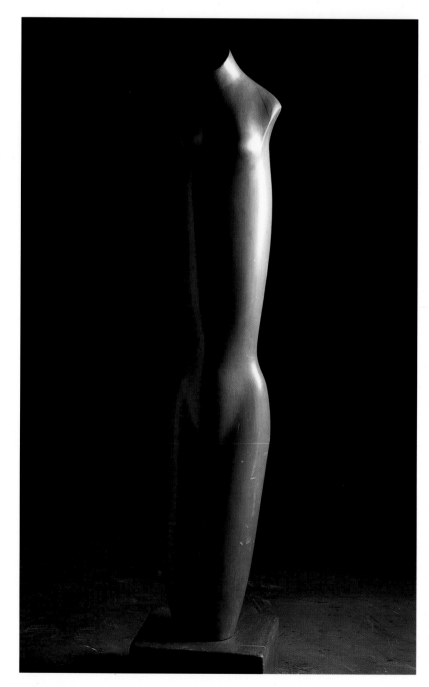

Slender Torso, 1948, Cedar

Seated Woman, 1989, Alabaster

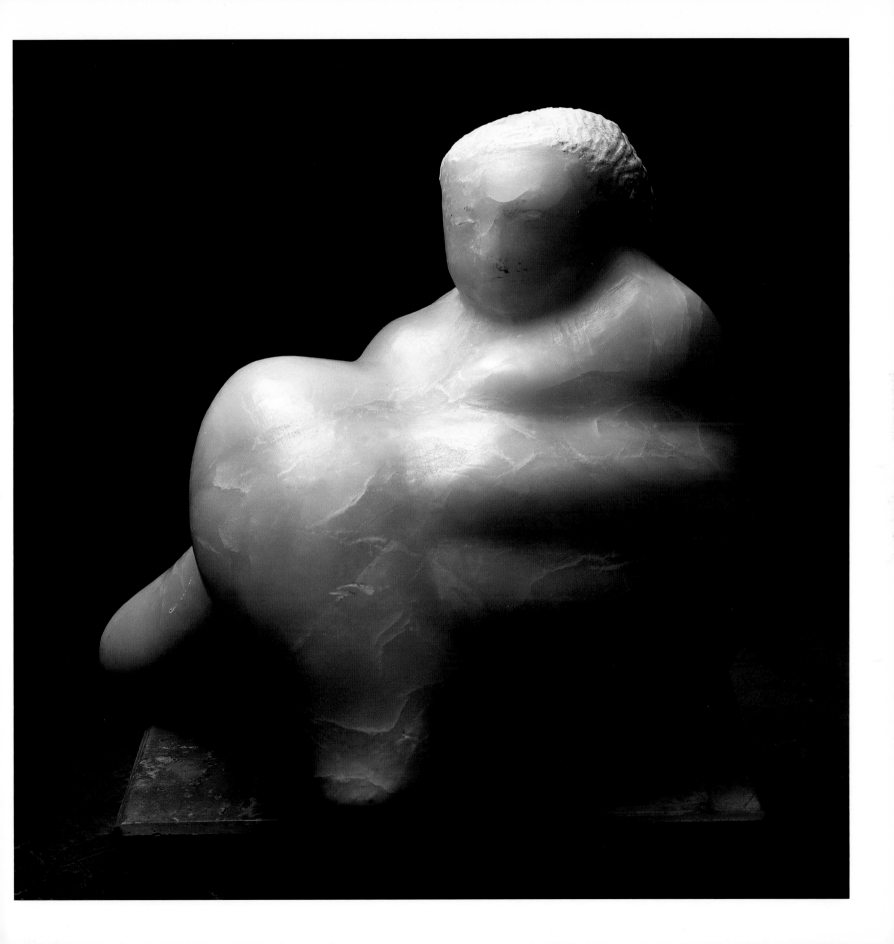

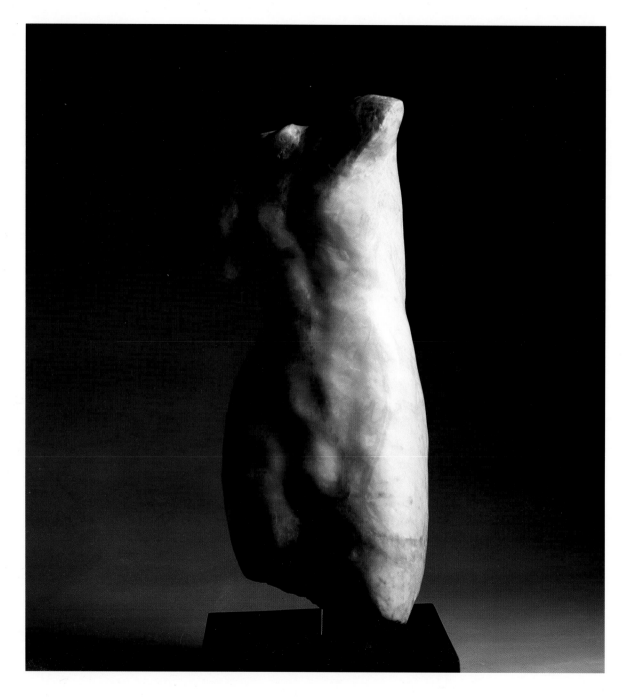

Female Torso, 1990, Marble

Flight of Birds, 1993, Alabaster

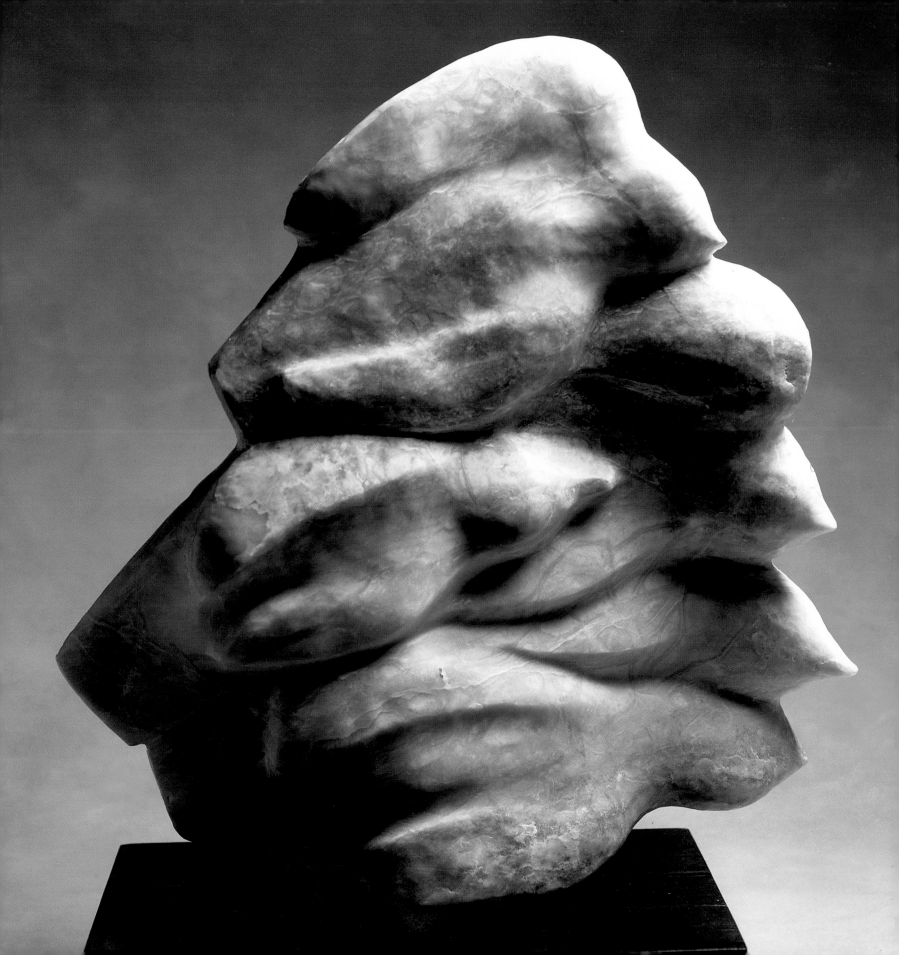

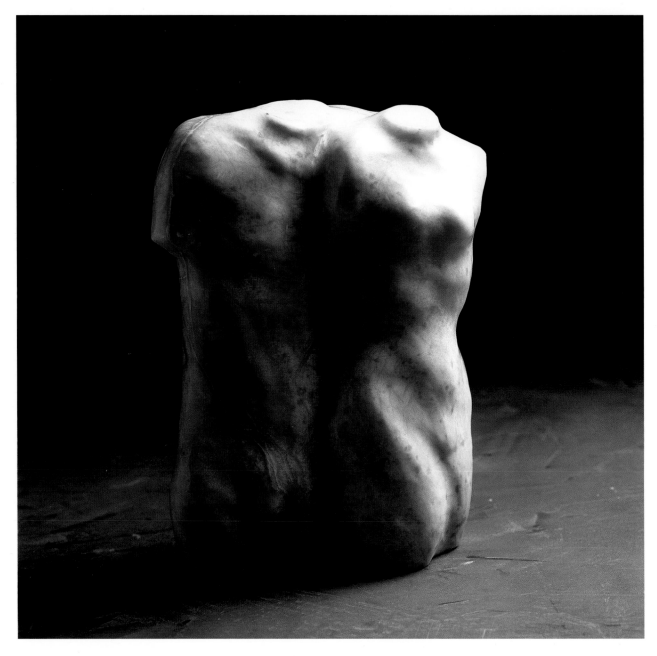

Double Torso, 1985, Alabaster

Translucent Head, 1991, Alabaster

Reclining Woman, 1997, Limestone (following pages)

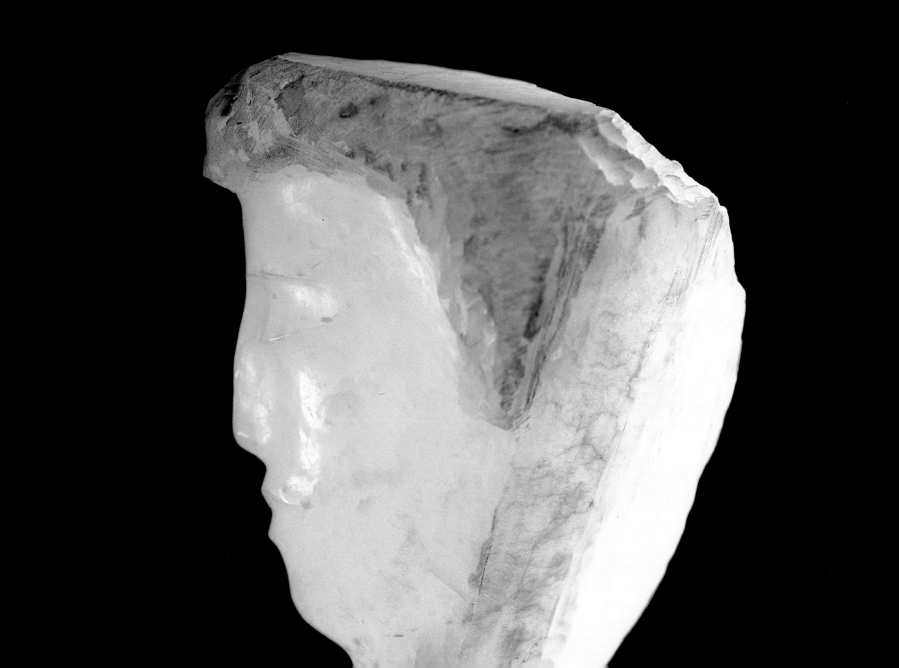

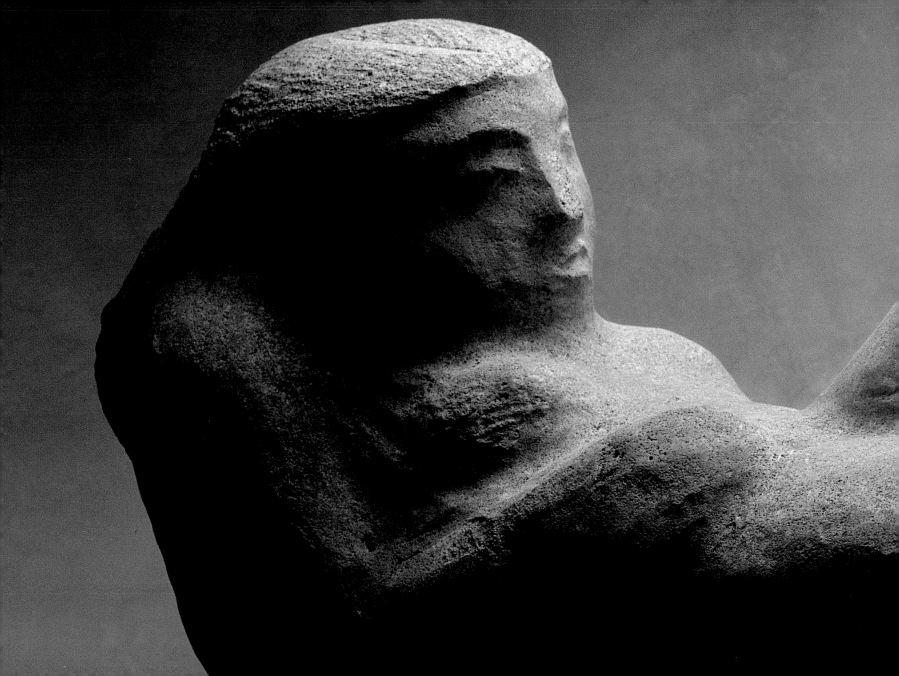

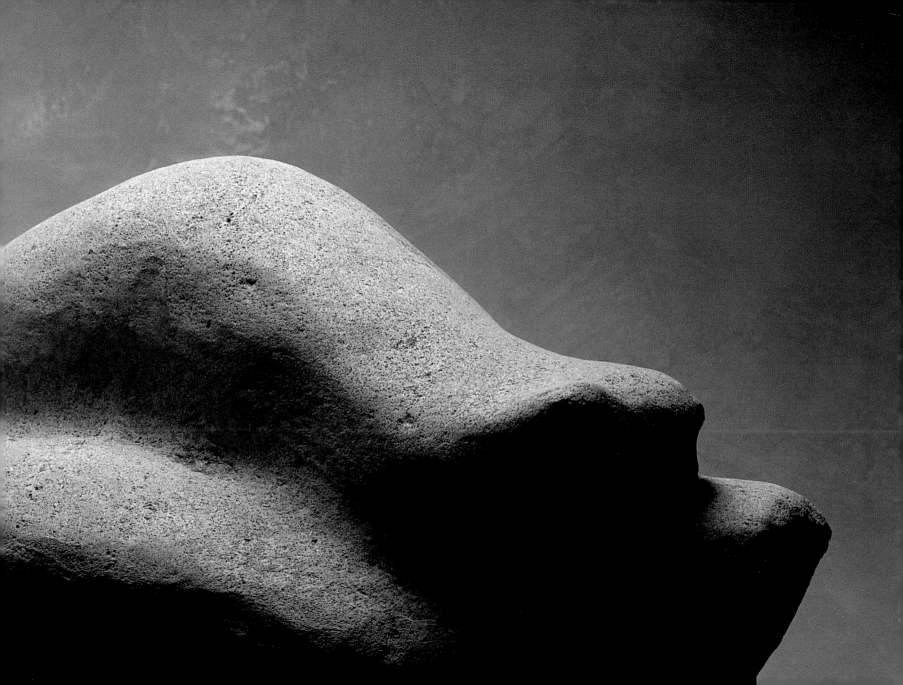

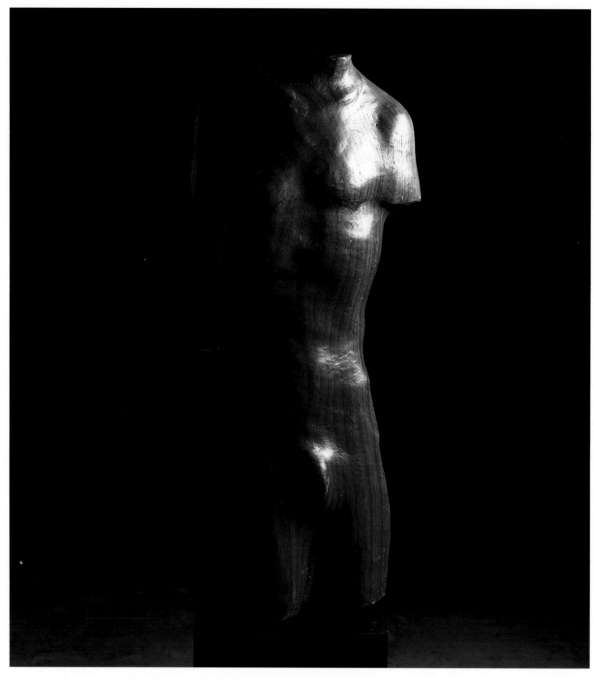

Male Torso, 1988, Walnut

Profile, 1994, Alabaster

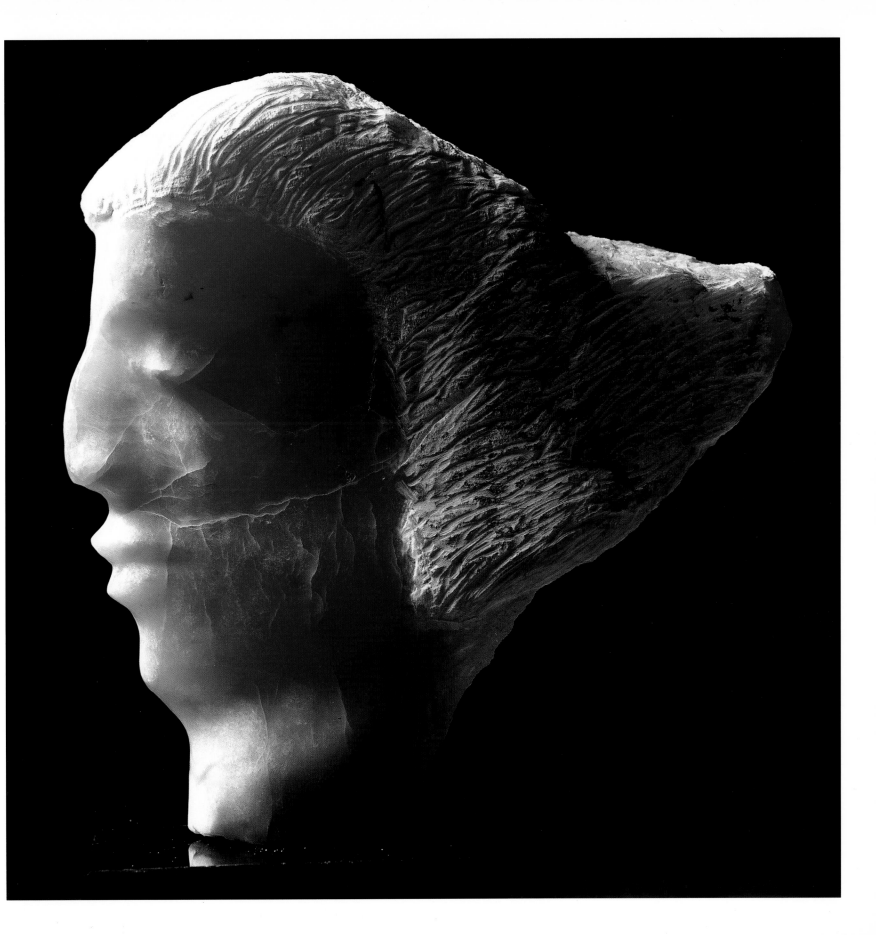

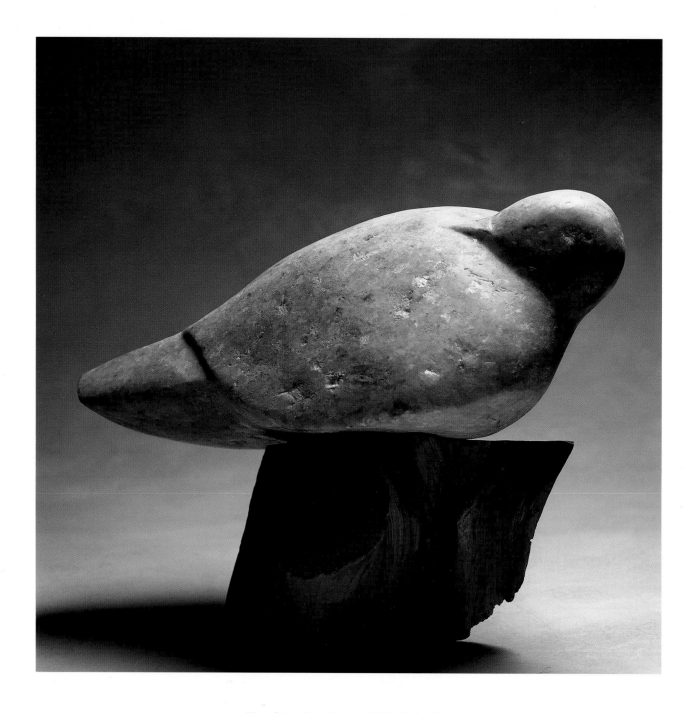

The Sleeping Dove, 1965, Dolomite

Bear, 1950, Porcelain

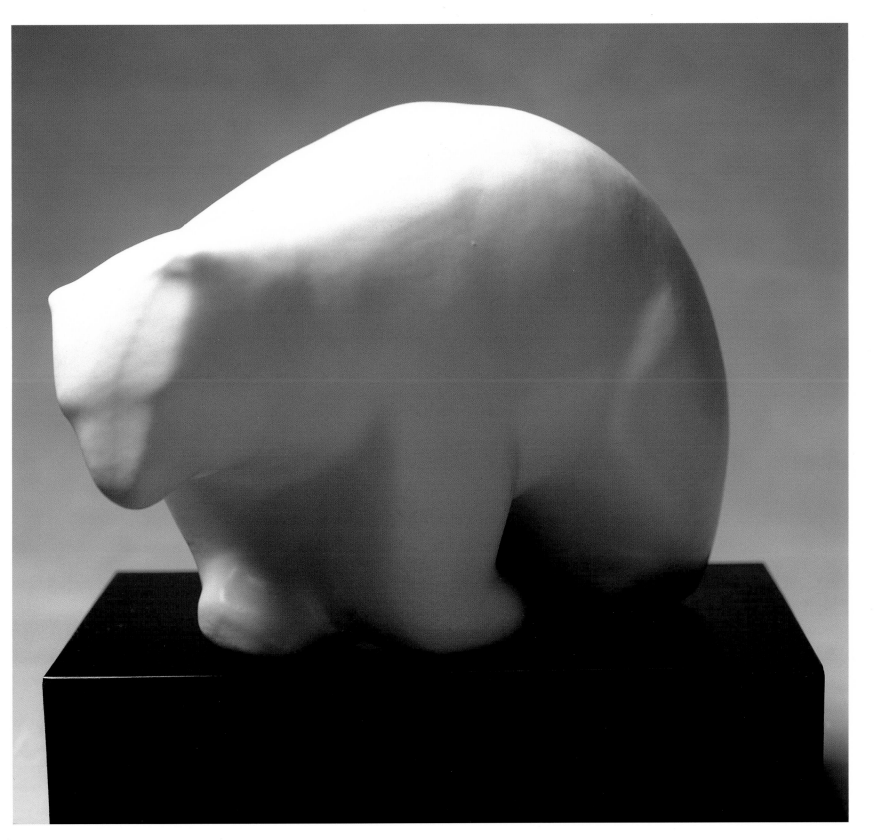

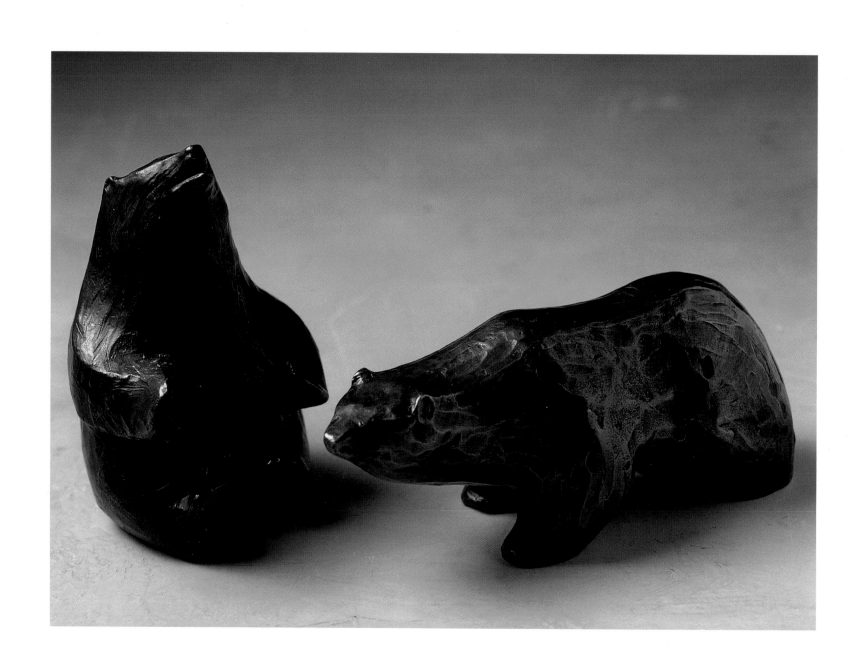

Bears from a collection of Canadian animals, 1980, Bronze

Girl Admiring a Trillium and Critical Blue Jay, 1953, Walnut

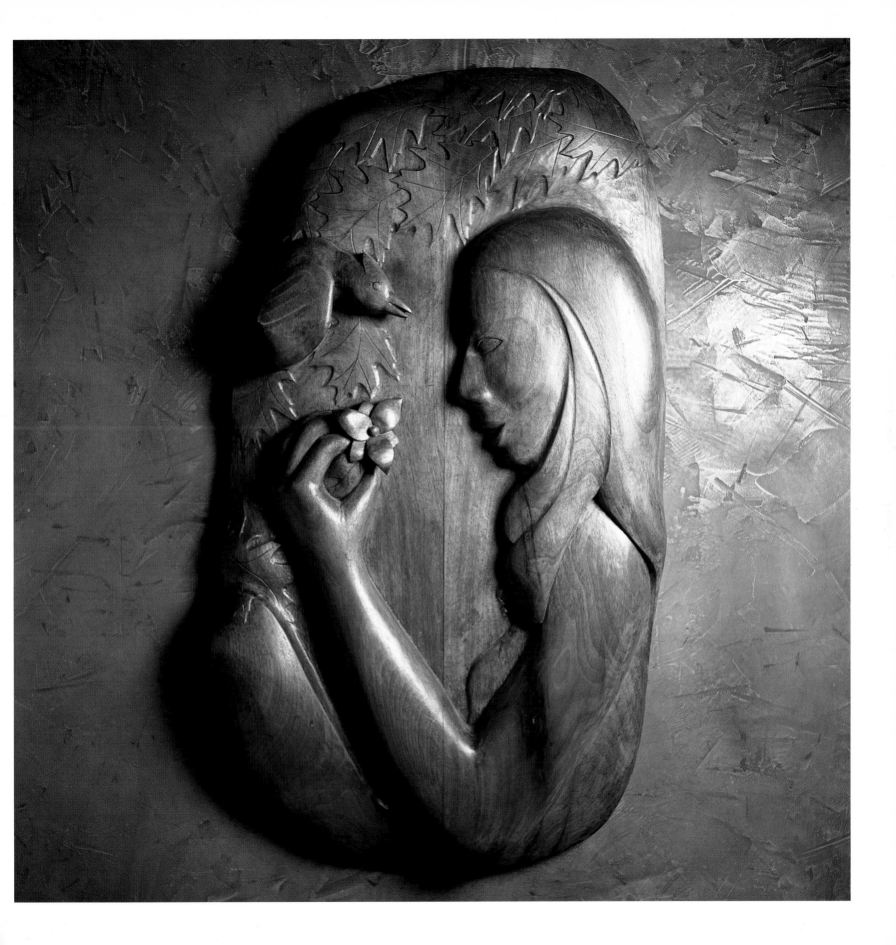

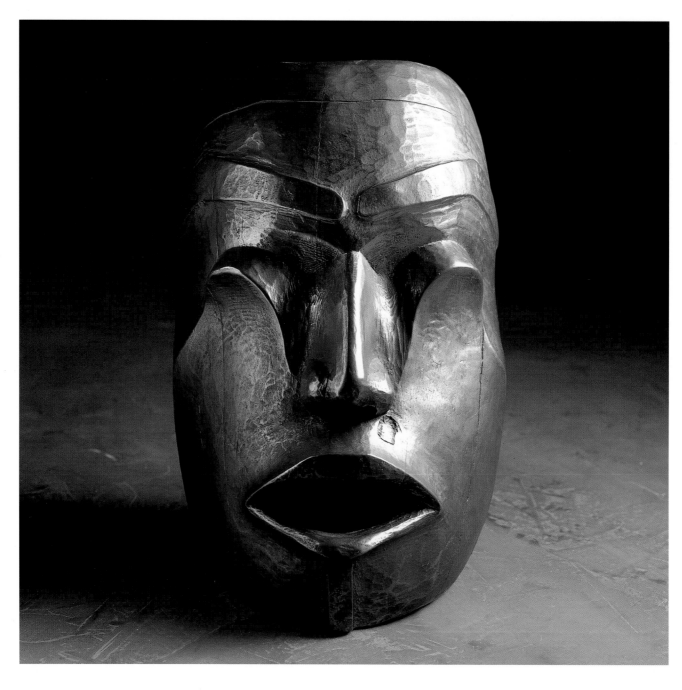

East Wind Mask, 1983, Bronze

Bird Mask, 1992, Wood and Abalone

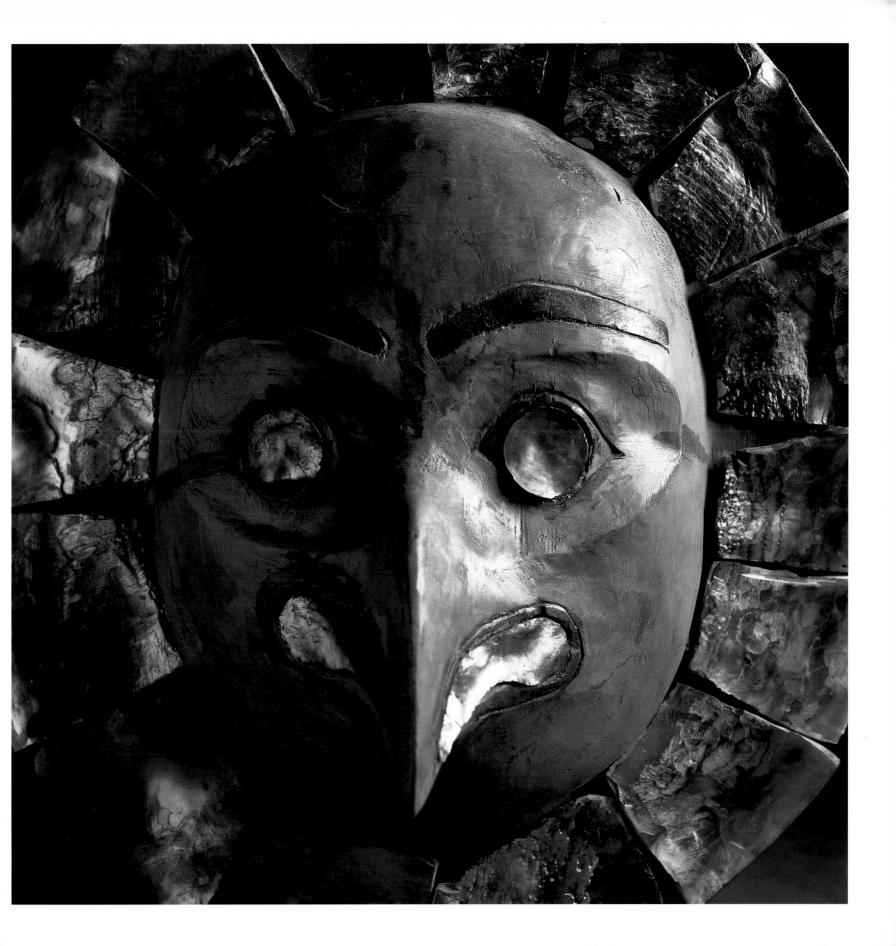

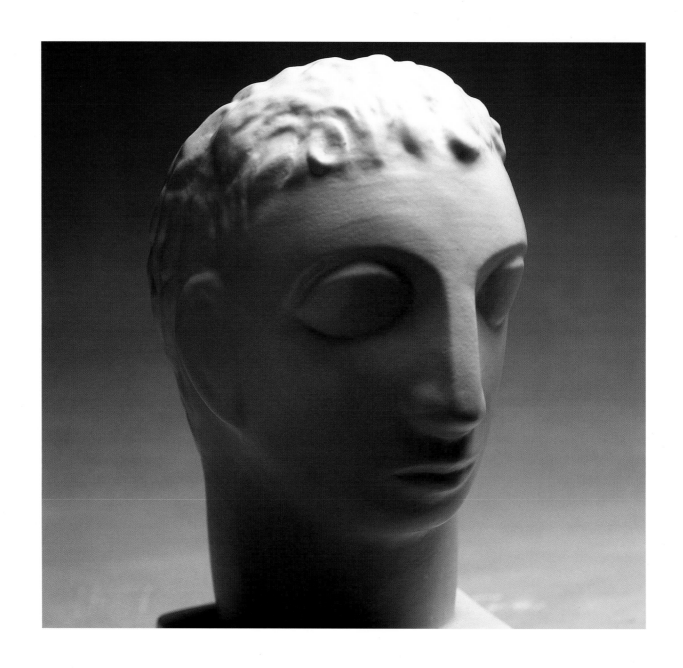

Man's Head, 1950, Porcelain

Female Torso, 1978, Northern Ontario Marble

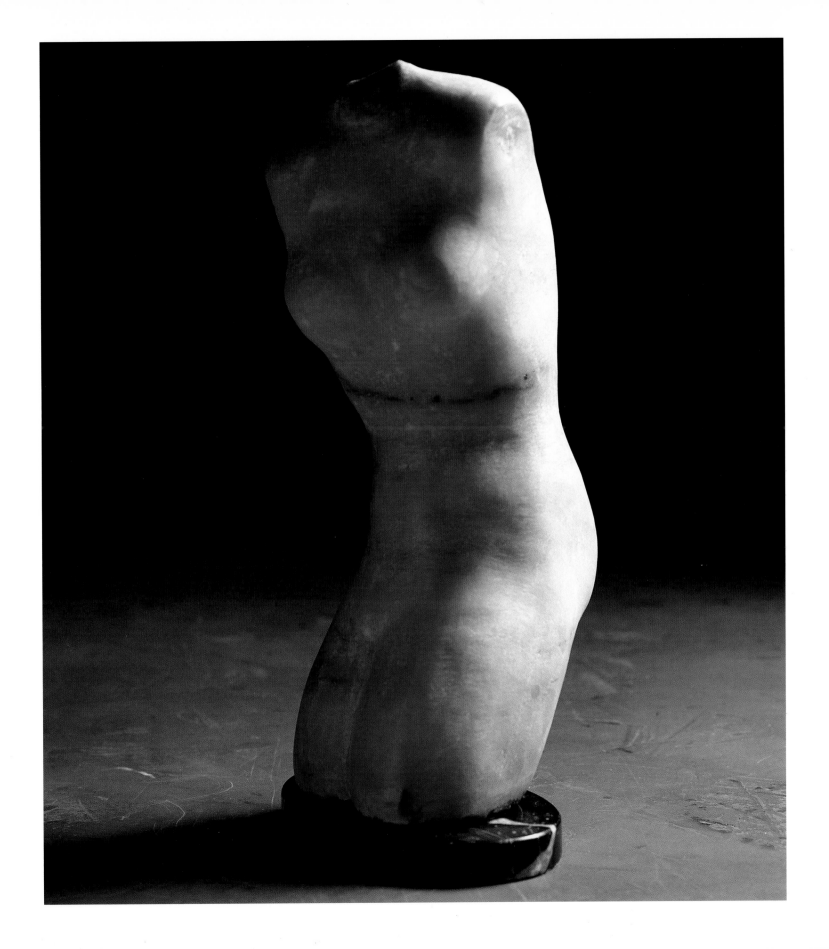

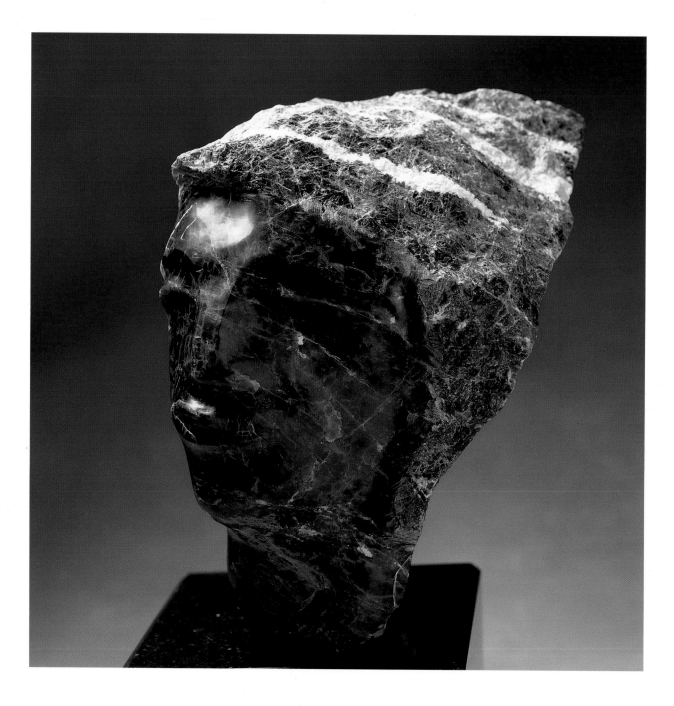

Girl's Head with Blowing Hair, 1987, Blue Sodalite

Reclining Figure, 1997, Alabaster

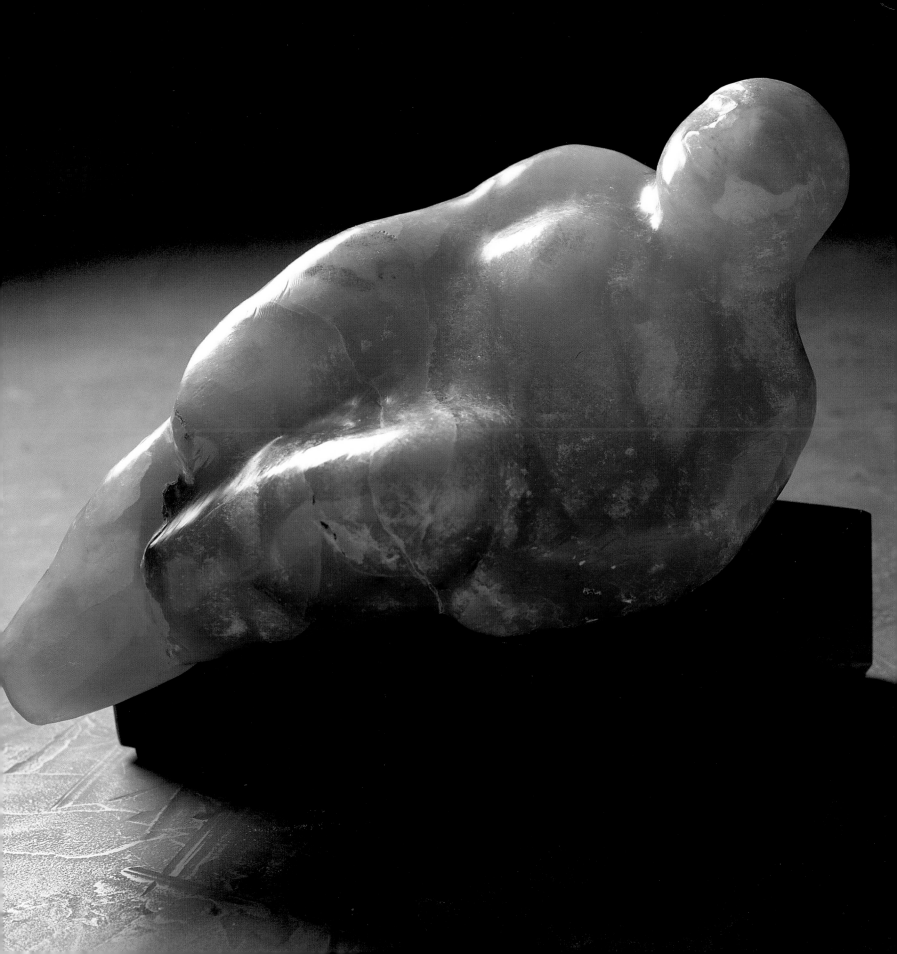

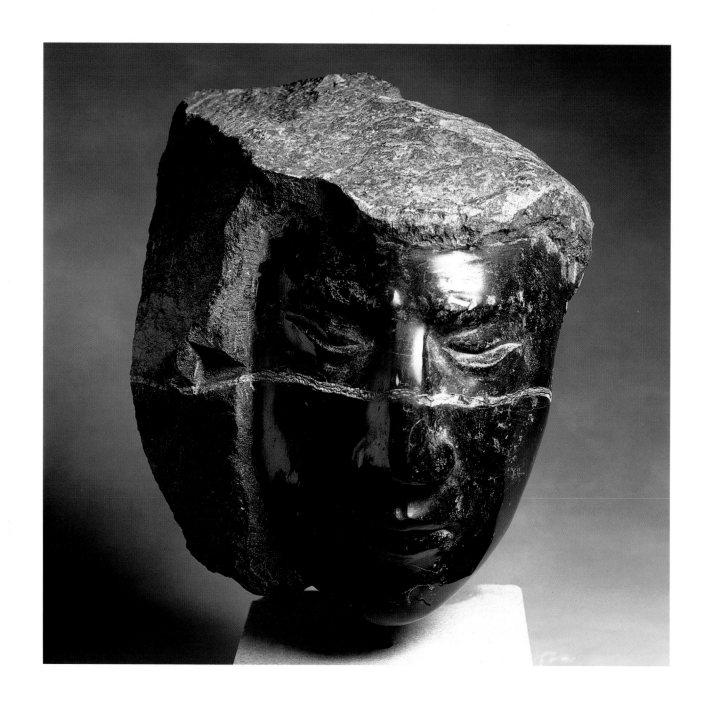

Head, 1972, Serpentine

Female Torso, 1989, Green Onyx

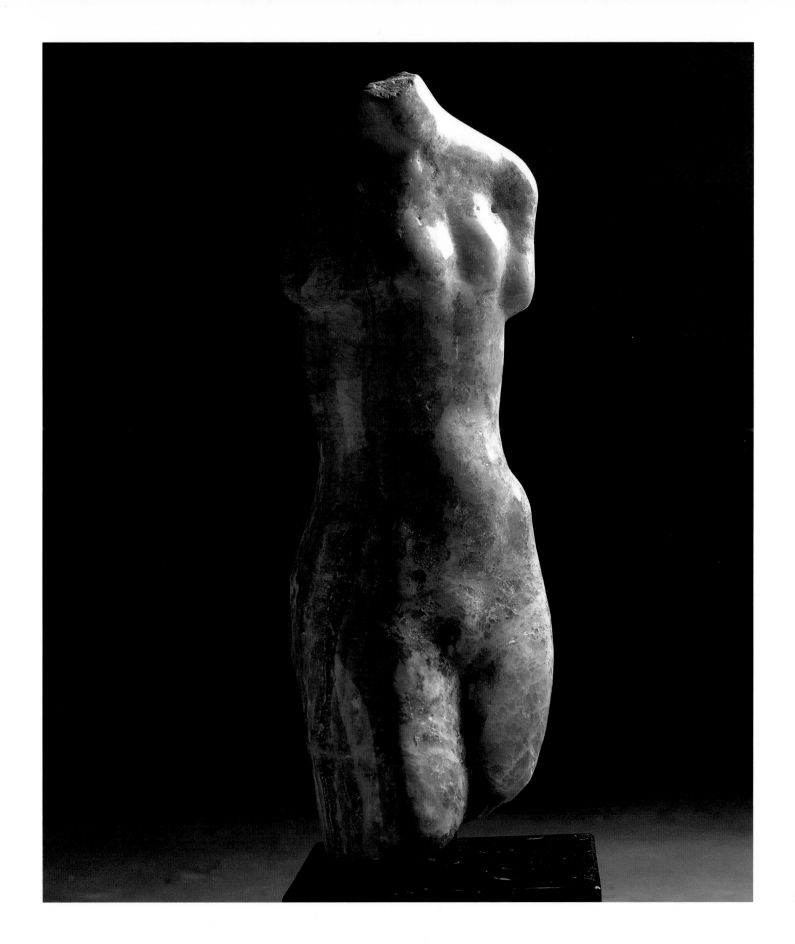

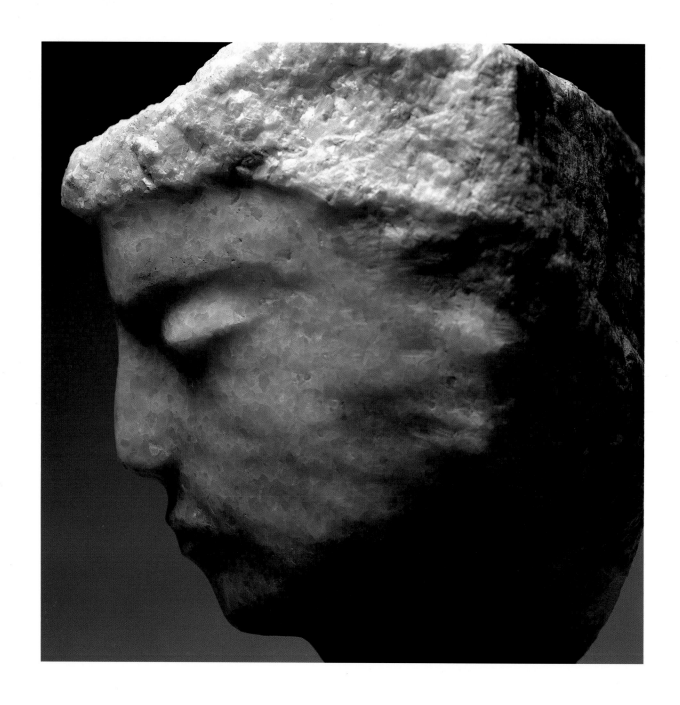

Profile Head, 1996, Alabaster

A collection of Alabaster heads created between 1989 and 1999

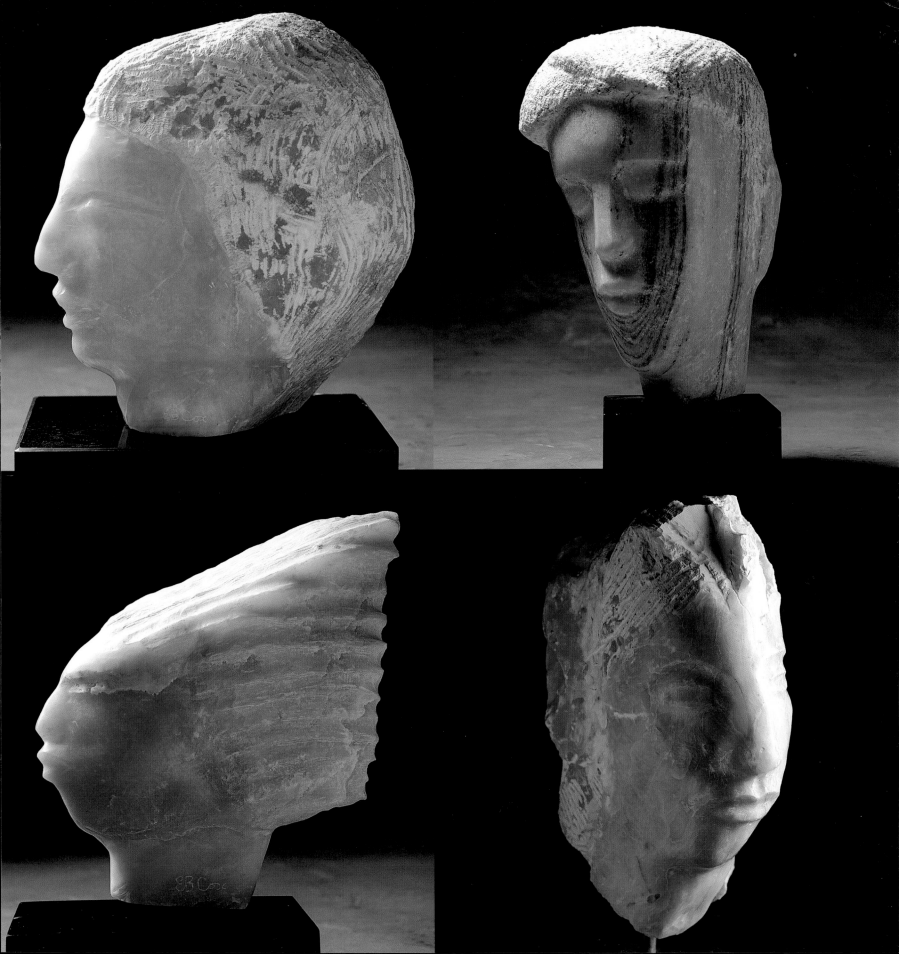

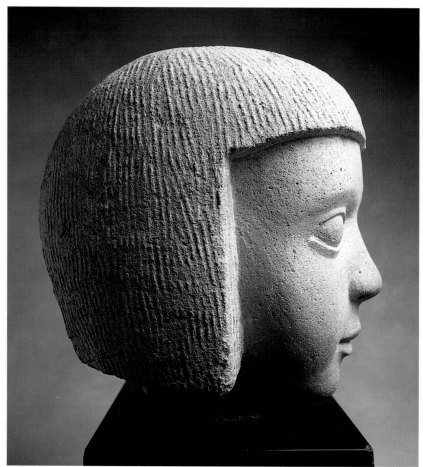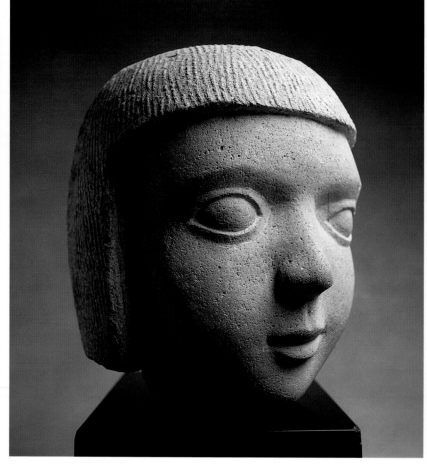

Kathy at 4, 1955, Limestone

Three Views

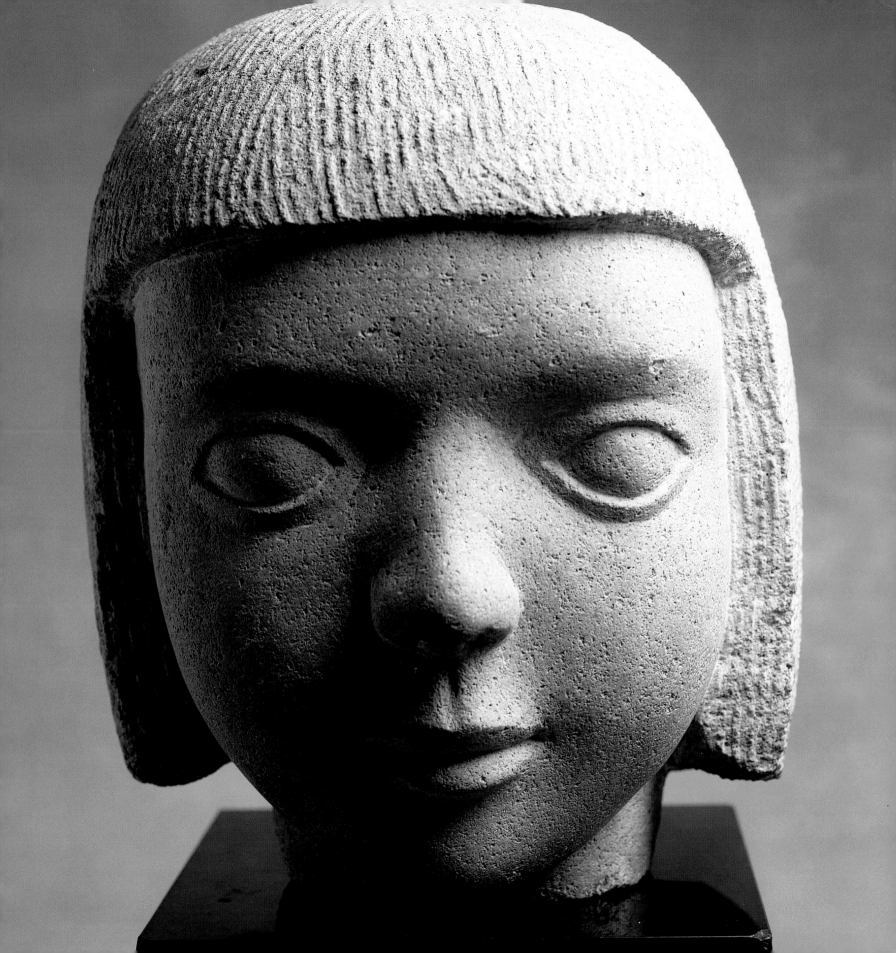

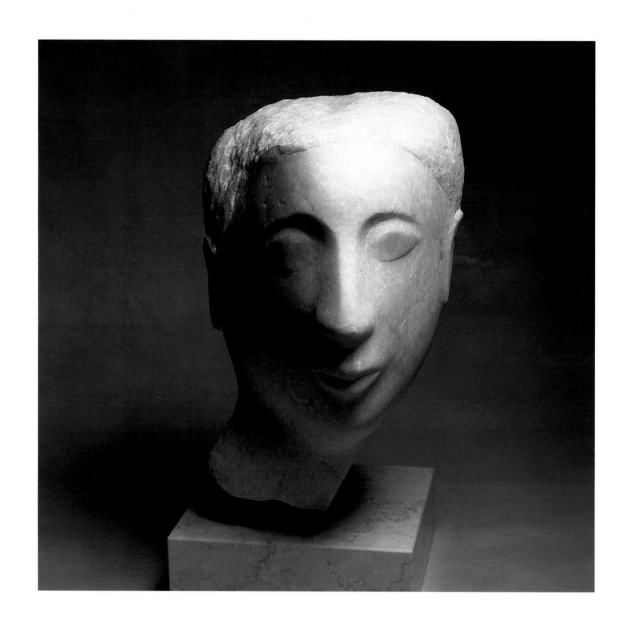

Head, 1960, Dolomite

Model for the Great White Lady, 1960, Bronze

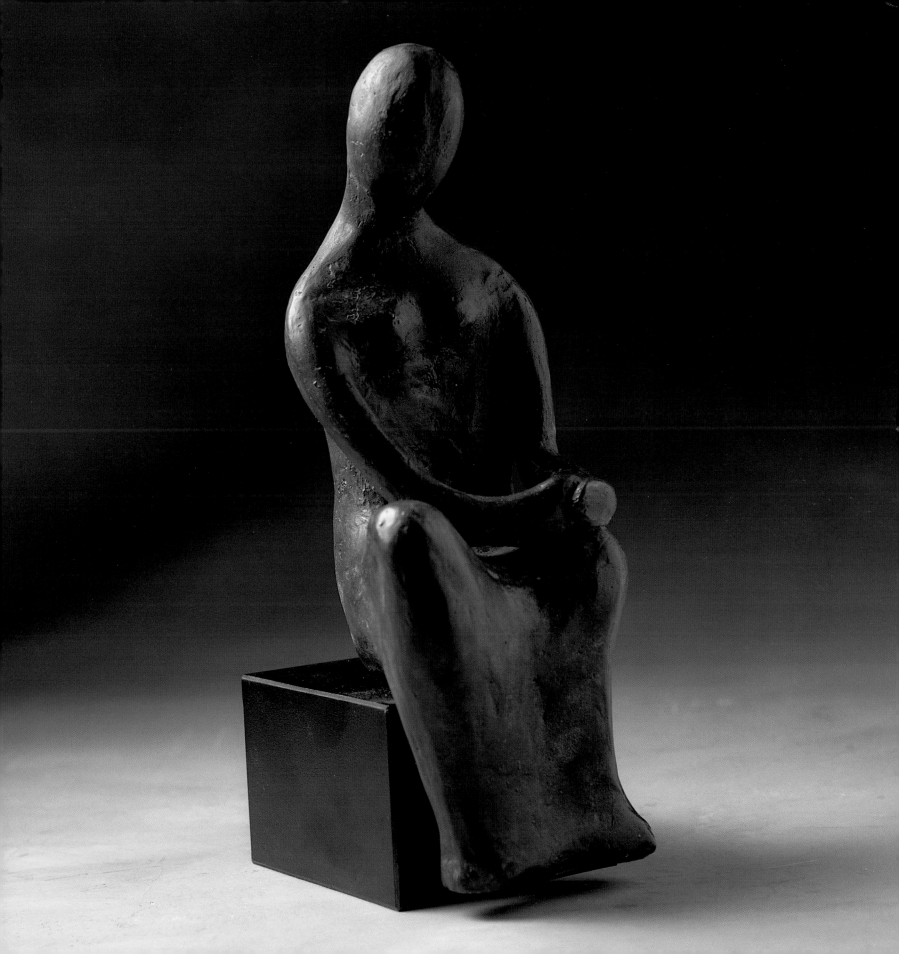

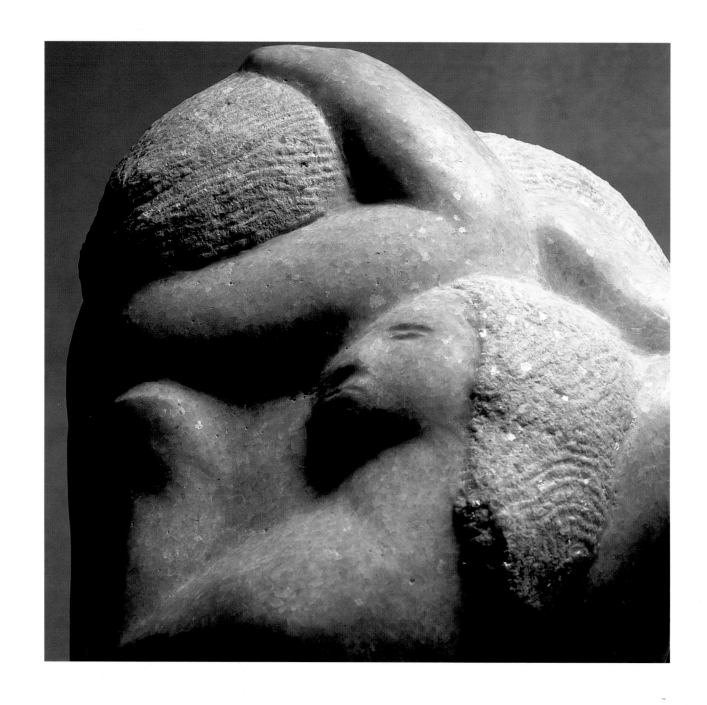

Family, 1989, Dolomite

Two Views

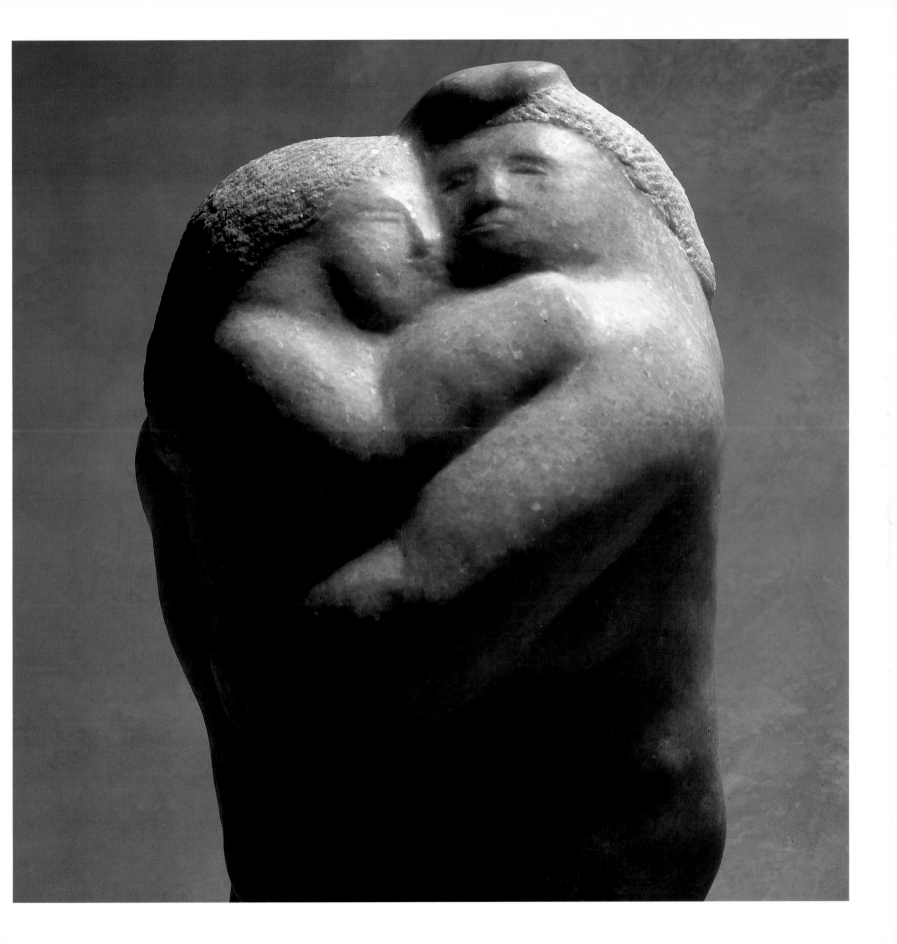

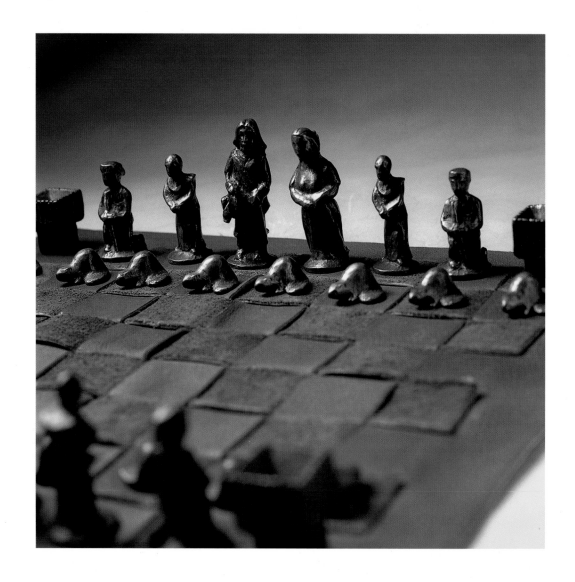

Canadian Chess Set, Bronze with Leather Board

Silver and Abalone Mask Pendant, 1983 (cw, top left)

Gold Mask Pendant, 1979

Gold and Abalone Mask Pendant, 1978

Silver and Sodalite Profile Pendant, 1980

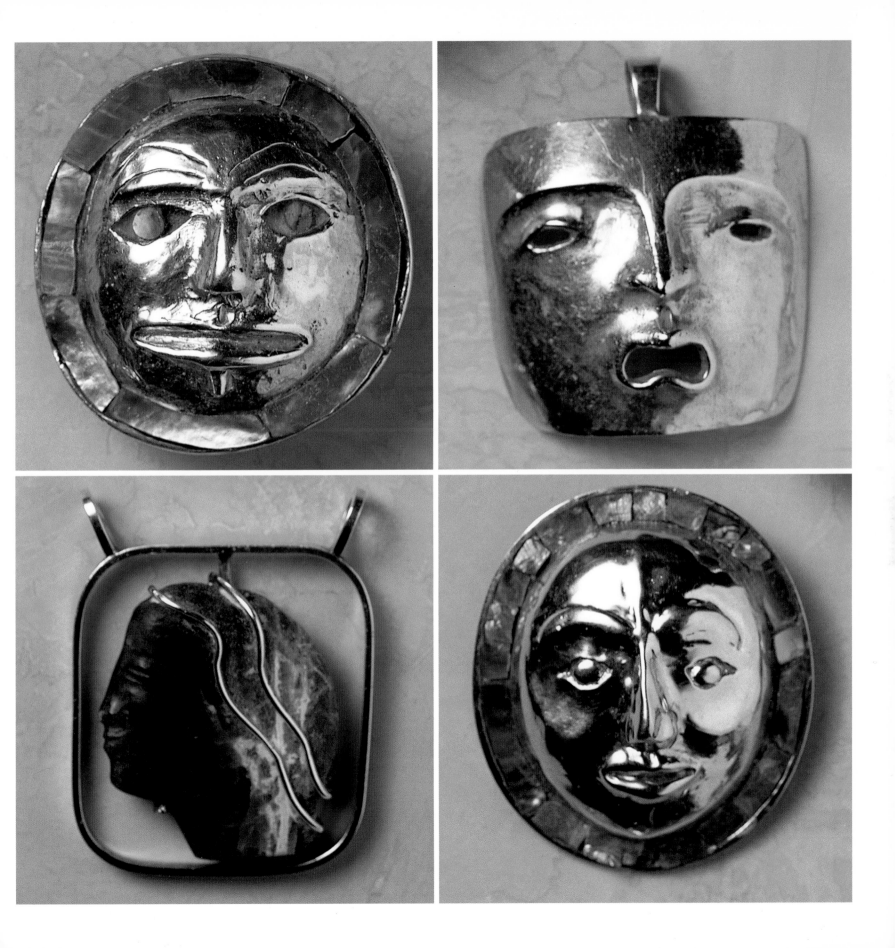

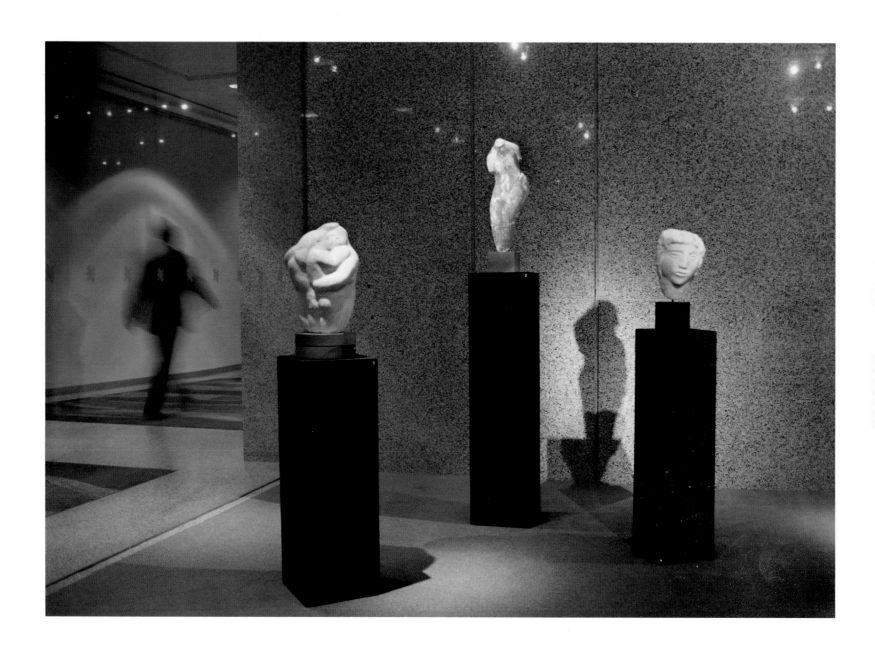

List of Collections

ART GALLERIES

Art Gallery of Ontario, Toronto, Ontario

Government of Canada, National Gallery Archives,
 Ottawa, Ontario

London Art Gallery, London, Ontario

Vancouver Art Gallery, Vancouver, British Columbia

PUBLIC COLLECTIONS AND INSTALLATIONS

Canadian National Exhibition, Toronto, Ontario

Clinton High School, Goderich, Ontario

Duke of Connaught Public School, Toronto, Ontario

Ernest C. Drury School for the Deaf, Milton, Ontario

Glendon College, East York, Ontario

Government of Ontario, Toronto, Ontario
 (MacDonald Block Quadrangle)

Guild Inn, Scarborough, Ontario

Halifax Airport, Halifax, Nova Scotia
 (relocated to archives of Maritime Museum)

Hart House, University of Toronto, Ontario

Leamington High School, Leamington, Ontario

Lewiston Public Library, Lewiston, New York

McMaster University, Hamilton, Ontario

Mimico Public Library, Mimico, Ontario

Niagara Falls Public Library, Niagara Falls, Ontario

North York Public Library, North York, Ontario

Peel County Court House, Brampton, Ontario

Victoria College, University of Toronto, Ontario

YMCA, Etobicoke, Ontario

Numerous other public schools throughout
 Southern Ontario

PRIVATE COLLECTIONS AND INSTALLATIONS

Lombard Place, Toronto, Ontario

Park Plaza Hotel, Toronto, Ontario

St. John's Anglican Church, York Mills, Ontario

Numerous private collections in Canada as well as
Australia, England, France, Japan, Mexico, Russia
and the United States

Notes on the Plates and Photography Credits

Dates noted on the captions adjacent to the photographs
are approximate.

The following notes provide further information not noted with the
photographs. Notes describe photographs from left to right unless
otherwise noted. Photographers are listed in italics when identity was
known. Approximate sizes are listed for the sculptures which appear
in pages 62-103.

With the exception of new photographs taken by Steven Evans in
the fall of 1998, all black and white photographs were archival
photographs owned by the artist. The photographers of these
pictures have been identified below when the identity was known.

TITLE PAGE
page 2: Portrait of E. B. Cox at age 85, *Deborah MacNeill*

FOREWORD
page 6: Portrait of E. B. Cox at age 21 painted by Barker Fairley,
Rob Davidson

E. B. COX: A LIFE IN SCULPTURE
page 12: The Home of the Artist, 1997, *Christopher Dew*
page 18: E. B. Cox at age 21, *John Glynn*
page 21: top left, E. B. Cox at Camp Ahmek, 1951; top right,
Ray Webber

THE CREATION OF THE GREAT WHITE LADY
page 24-28: The Creation of the Great White Lady, 1960–61,
Ray Webber
page 29: E. B. Cox Revisits the Great White Lady, 1995,
Catherine Bolger

THE GARDEN OF THE GREEK GODS
page 32: Return to the Garden of the Greek Gods 1982, taken at
Canadian National Exhibition, photographer unidentified
page 32-41: The Garden of the Greek Gods, all photographs except
top left of page 32 were taken at original site at Georgian Peaks
1963, *Ray Webber*; The following sculptures are not shown: Cyclops,
Harpies, Hydra, Phoenix, Seahorse, Sphinx, Typhon.

EARLY WORK AND INSTALLATIONS
page 44: Learning and Nature relief being installed by E. B. Cox
at Leamington High School, 1952, *Fisher's Studio*
page 50: Draped Figures located at Margaret Addison Residence,
Victoria College, *Ray Webber*
page 51: Seated Lady, *Ray Webber*
page 53: Mother and Child, *Steven Evans*
page 54: Spring Break-up is a fountain located at the
Park Hyatt Hotel, Toronto formerly the Park Plaza Hotel.
page 55: Deer at Water, *Steven Evans*
page 58-59: Stone animals at Ernest C. Drury School for the
Deaf, Milton, Ontario, *Steven Evans* (Additional sculptures
not shown are Bear, Rabbit and Swan.)

FROM THE PRIVATE COLLECTIONS
page 62 - 103: All colour photographs on these pages were taken by
Rob Davidson in December 1998.

Approximate sizes are noted by page number.
Sizes refer to photo from left to right unless otherwise noted.

Page 62: Height 15.24 cm; page 63: height 24 cm; page 64: height
33.02 cm, height 30.38 cm; page 65: height 30.48 cm; page 67:
height 30.48 cm; page 66: Height 27.94 cm; page 67: height 20 cm,
length 36 cm; page 68 and page 69: height 30 cm; page 70 and 71:
height 33.02 cm, length 27.94 cm; page 72: height 76.20 cm; page
73: height 22.86 cm; page 74: height 35.56 cm; page 75: height
45.72, width 44.45 cm; page 76: height 20.32 cm; page 77: height
19 cm; page 78-79: height 25 cm, length 65 cm; page 80: height
30.48; page 81: height 30.48 cm; page 82: height 11.43 cm
(excluding driftwood base); page 83: height 15.24 cm, Length 22.06;
page 84: left, height 9.52 cm, right, height 7.62, length 12 cm; page
85: height 76.20 cm, width 45.72 cm; page 86: bronze mask cast in
1983 was executed from wood mask carved by E. B. at age 21,
which was based on an original mask at the National Gallery of
Canada, height 29.21 cm; page 87: Bird Mask was inspired by
Haida Masks, height 33 cm; page 88: height 19.05 cm; page 89:
height 26.50 cm; page 90: height 20.32 cm; page 91: height 30 cm;
page 93: height 30.5 cm; page 94: height 21.84 cm; page 95: top
left, height 25 cm, top right, 26.03 cm; bottom left, height 19.05 cm,

bottom right, height 35 cm; page 96 and 97: height 22.22 cm; page 98: height 39.37 cm; page 99: height 20.86 cm; page 100 and 101: height 43.18 cm; page 102: Chess Set was intended to be uniquely Canadian in theme, with a beaver for pawn, trapper for knight, missionary for bishop, log fort for castle, and factor and wife for king and queen; page 103: top left, diameter 5.08 cm, top right, diameter 3.81 cm, bottom left, 4.45 cm, bottom right, diameter 3.18 cm.

COLLECTIONS
page 104: Exhibition at the Sculptors' Society of Canada
 Gallery, Toronto, November 1998, *Deborah MacNeill*

NOTES ON THE PLATES AND PHOTOGRAPHY CREDITS
page 107: Limestone panel from the west side of
 Glendon College doorway, 1965, *Steven Evans*

LAST PAGE
page 108: E. B. Cox and Wooden Masks, 1998,
 Deborah MacNeill

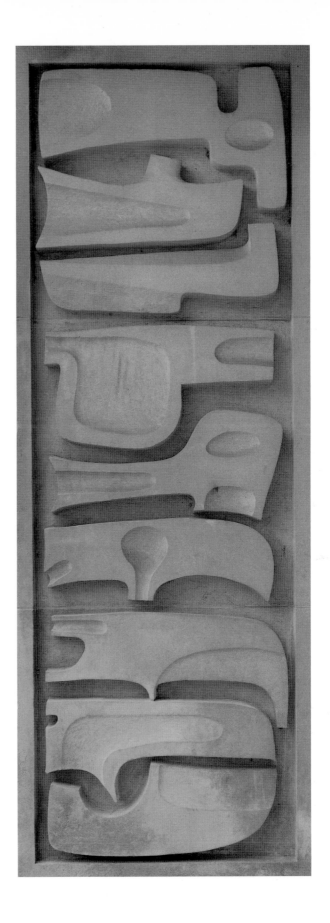

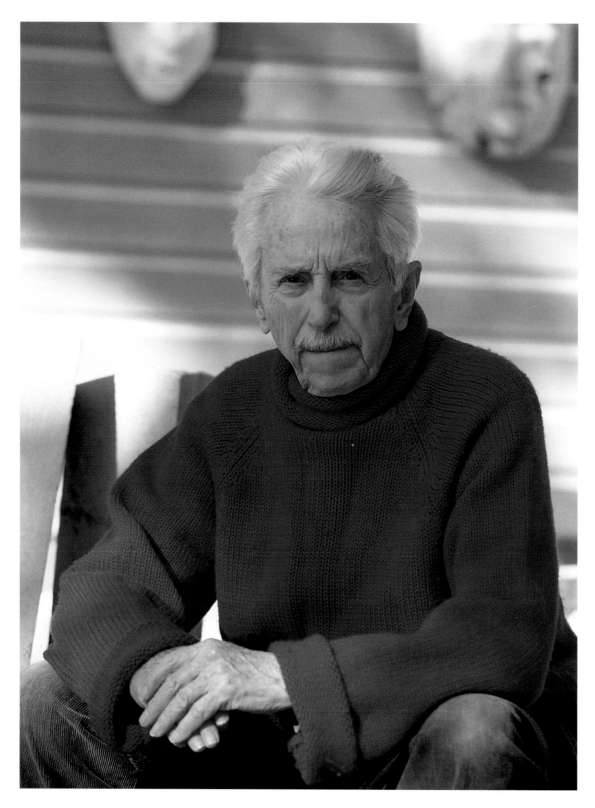

"I make beautiful things for other people"
E. B. Cox